IMAGES
of Rail

THE BALTIMORE AND OHIO RAILROAD IN WEST VIRGINIA

To Leroy—
God bless you!
Bob Withers
Oct. 20, 2012

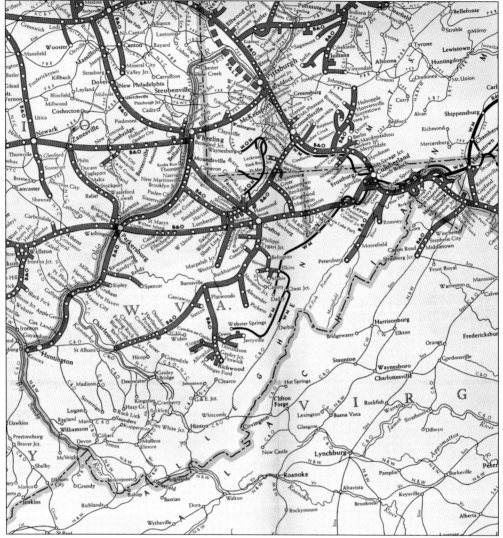

Long before the Baltimore and Ohio Railroad (B&O) was merged into CSX Transportation in 1987, it dominated northern and central West Virginia, carrying passengers through the Mountain State's hills and hollows and hauling millions of tons of its coal to market. B&O's Baltimore–St. Louis main line tapped resources in other parts of the state with a network of feeder and branch lines. (Base Map © Rand McNally, R.L.07-S-55/Bob Withers collection.)

ON THE COVER: It is about 8:00 a.m. on Monday, February 26, 1951, as members of the midnight yard crew and just-arrived Freight Train 93 pose with the Huntington yard engine. On the ground are, from left to right, Thomas Bradbury, night helper; Chester "Shorty" Duvall, night foreman; Ernest Griffith, 93's flagman; and George "Tater" Wallace, car inspector. Yard engineer Harry Burford sits in the locomotive cab. (Charles Lemley/Bob Withers collection.)

IMAGES
of Rail

THE BALTIMORE AND OHIO RAILROAD IN WEST VIRGINIA

Bob Withers

ARCADIA
PUBLISHING

Published by Arcadia Publishing
Charleston SC, Chicago IL, Portsmouth NH, San Francisco CA

Printed in the United States of America

Library of Congress Catalog Card Number: 2007925496

For all general information contact Arcadia Publishing at:
Telephone 843-853-2070
Fax 843-853-0044
E-mail sales@arcadiapublishing.com
For customer service and orders:
Toll-Free 1-888-313-2665

Visit us on the Internet at www.arcadiapublishing.com

*To all the friendly B&O railroaders who endeared their industry to a
little boy who never stopped asking them questions.*

This logo—and several similar ones—adorned B&O rolling stock for decades, advertising the
fact that the railroad served virtually all the Northeastern section of the United States.

CONTENTS

ACKNOWLEDGMENTS

Without the railroaders and rail fans who recorded the images you are about to enjoy, this book would not have been possible. Train crews, officers, and clerks took pride in each other and their work, recording their efforts so future generations would learn what a steam engine looked like and how travel was conducted in the good old days. Railroad enthusiasts and members of the general public took the cue and did the same thing, benefiting those who were born too late to experience that world in person.

Specifically, railroaders whose photographic work and memories are included herein include H. D. Bee, Cliff Bellamy, F. Douglas Bess, Ralph W. Brafford, Dave Corbitt, Larry K. Fellure Sr., Gary E. Huddleston, Charles B. Hughes, Joseph R. Krupinski, Charles Lemley, Lloyd D. Lewis, Robert G. Lewis, V. Wayne Mason, Charles and Esther Morrow, O. V. Nelson, Charles S. Ruddell, Harold Wetherall, and Don Whitlatch.

Others individuals and agencies whose archives, talents, and assistance have been tapped include Howard Ameling; Winnie Arthur; Charles W. Aurand; Luther Baker; the Baltimore and Ohio Railroad Historical Society, Inc.; the B&O Railroad Museum, Inc., Hays T. Watkins Research Library; Garland T. Brown; Lawrence V. Cartmill; *Classic Trains* magazine; Richard J. Cook; C. R. Davidson; Stephen P. Davidson; Helen Diddle; Thomas W. Dixon Jr.; the Dwight D. Eisenhower Presidential Library; Steve Exum; Bruce Fales; Steve Ferrell; Dan Finfrock; Minnie Finley; Don Flesher; Bob Freitag; Paul Fulks; W. J. B. Gwinn; Leo Harmon; Herbert H. Harwood Jr.; Philip R. Hastings; Ken Hechler; the *Herald-Advertiser*; the *Herald-Dispatch*; Eloise Hines; Nancy Hirzel; the *Huntington Advertiser*; the Interstate Commerce Commission; Gordon C. Jackson; John P. Killoran; John King; Fred Lambert; Mid-America Paper Collectibles; Charlotte Dugan Moore; O. S. Nock; Gladys Paden; the *Parkersburg News*; the *Richwood News Leader*; Capt. Russell Stone; Nancy Taylor; TLC Publishing, Inc.; Harold K. Vollrath; William E. Warden Jr.; Jan Weiford; Scott West; Jay Williams; and J. J. Young Jr.

The 21st-century public owes them, and many others like them, a debt of gratitude for their efforts to keep railroad history alive.

Connecting Service from Hinton and Charleston, W. Va.

			* 1.40	* 6.45	* 6.45	* 6.35
0.0	Lv **Hinton**, W.Va. (C. & O.)					
97.0	Lv **Charleston** (C. & O.)		3.47	9.00	9.00	8.55
147.0	Ar **Huntington** (C. & O.)		4.44	10.10	10.10	9.52
0.0	Lv **Charleston** (N. Y. C.)			† 6.50		* 4.45
57.1	Ar **Point Pleasant** (N. Y. C.)			8.50		6.06
			AM	AM	AM	PM

Miles	West Virginia Stations.	**EASTWARD** (Read Down)	Opposite Ohio Stations.	82 Mixed	72	720	78 36
		(EASTERN STANDARD TIME)		AM	AM	AM	PM
0.0	Lv **Kenova**, W. Va.			† 5.40	†11.10	§11.10	*10.05
1.0	Ceredo						
5.6	West Huntington			f 5.50		f11.18	
8.2	**Huntington**	Chesapeake, O.		6.08	11.40	11.40	11.10
11.6	Guyandotte	Proctorsville, O.		f 6.18		f11.47	
17.5	Cox Landing			f 6.37		f11.55	
20.1	Lesage			f 6.41		f11.59	
21.8	Millersport	Miller, O.					
23.0	Green Bottom			f 6.45		f12.03	
24.9	Crown City	Crown City, O.		f 6.52		f12.06	
26.6	Homestead			f 6.54		f12.08	
27.9	Clover						
30.2	Glenwood			f 7.02		f12.13	
32.8	Ashton			f 7.07		f12.16	
34.4	Mercers Bottom						
35.3	Appl						

This page from the B&O Railroad's April 25, 1948, timetable shows the eastbound trains running on the Ohio River line between Kenova and Wheeling. Trains 72 and 78 made connections to Pittsburgh, and Train 78 carried a Hinton-to-Pittsburgh sleeper via the Chesapeake and Ohio Railway to Huntington. The schedule also included mixed Train 82 between Kenova and Parkersburg. (Bob Withers collection.)

INTRODUCTION

West Virginia's history and growth always has been associated with that of the Baltimore and Ohio Railroad (B&O), which predated the state's formation by 36 years.

The B&O was chartered in 1827 to operate between Baltimore and the Ohio River by Maryland capitalists who feared their city would be left out of the lucrative East Coast-to-Midwest trade that other eastern cities were developing. With the early 19th-century turnpikes and the National Road, Baltimore was well positioned for that traffic, until the opening of the Erie Canal in 1825 gave New York a tremendous advantage with its level and inexpensive access to the very territory Baltimore was targeting.

Railroads in England were in their infancy, but Baltimore's desperate bankers and merchants were convinced they had to gamble on the new technology. Construction began on July 4, 1828, following a parade and the ceremonial laying of a cornerstone in which Charles Carroll of Carrollton, last surviving signer of the Declaration of Independence, participated. The B&O thus became the United States' first common-carrier railroad.

The company started the country's first regular passenger service over its first 13 miles of trackage from Baltimore to Ellicott's Mills on May 24, 1830. Horses provided the earliest motive power until suitable steam locomotives—with tiny vertical boilers—could be developed.

Among the earliest riders were former president John Quincy Adams, en route from Massachusetts to Washington, D.C., on December 17, 1830, to begin serving in the House of Representatives, and Pres. Andrew Jackson—the first sitting president to try out "the carrs [sic]"—on June 6, 1833, as part of a tour to combat the northeastern states' divisive "nullification" doctrine.

The railroad entered what is now West Virginia at Harpers Ferry in December 1834 and crossed back into Maryland at Cumberland in November 1842. Political pressure kept the B&O out of Pennsylvania at first, and so track crews headed westward, back into West Virginia and across the Allegheny Mountains—and their formidable grades of up to 2.2 percent—to the Ohio River town of Wheeling.

The torturous mountain route plagued construction, and crews took until May 1852 to reach Grafton. From there, work proceeded apace. Crews arrived in Fairmont in June, and on Christmas Eve, gangs working from both directions completed the 379-mile line at Roseby's Rock, a remote spot 18 miles southeast of Wheeling. The first train from Baltimore to the Ohio arrived in Wheeling on New Year's Day, 1853.

Even before the line was completed, B&O realized it had made a mistake by heading for a town so far north on the river. It backed construction of the North Western Virginia Railroad, which struck out from Grafton in 1852 and reached the river town of Parkersburg, 93 miles south of Wheeling, in 1857. Through affiliations and mergers in subsequent years, this route became B&O's main line between Baltimore and St. Louis.

In 1861, the railroad found itself in the crosshairs of the Civil War because it virtually straddled the boundary between North and South and served as Washington's only rail outlet to the North. It quickly became a pawn for both sides, even though President Lincoln pressured B&O president John W. Garrett to keep it on the Union side.

The company helped keep the nation together during the first major war during which railroads played a pivotal role, but the cost was high. Much of its property was wrecked and rebuilt, in some cases several times. Among the most severe losses were its engine facilities at Martinsburg and the original bridge across the Potomac River at Harpers Ferry.

Following the conflict, many of B&O's corporate decisions rendered it an underdog in a northeast market dominated by the Pennsylvania and New York Central railroads. As a result, it often grew by taking over smaller roads no one else wanted. But what the company lacked on the bottom line was greatly compensated for by the hospitality and helpfulness of its people. It is said that Pres. Franklin Roosevelt preferred B&O to the Pennsylvania when he went home to Hyde Park, New York, in part because of its down-home attitudes.

B&O enjoyed one other advantage—vast deposits of West Virginia coal, which began flowing toward the East in the mid-1840s and have not abated to this day. That led the railroad to finance and/or acquire, by 1917, a spiderweb of branch lines that covered much of the northern and central parts of the Mountain State. For 70 years thereafter, B&O operated all those acquisitions as a single carrier, helping to link "13 great states with the nation," as the company's slogan said.

The fact that B&O was the only east-west line passing directly through Washington handed it some notable passengers, including most U.S. presidents and occasionally British royalty. Perhaps some of the most unique passengers included a party from the Library of Congress escorting the original U.S. Constitution, Declaration of Independence, and other valuable artifacts from the nation's capital to the gold bullion depository in Fort Knox, Kentucky, in a sleeping car room aboard the *National Limited* for safekeeping during World War II. The precious cargo passed through West Virginia—unknown to the train's other passengers—in the wee hours of December 27, 1941.

The company's familiar postwar paint scheme of blue and gray with yellow trim bespoke of the company's Civil War heritage. Its finely tuned *Timesaver* and *Sentinel Service* freight trains hauled all kinds of goods on fast schedules that ran around the slow, ponderous coal drags. The railroad developed a unique personality, fostered by the fact it reached some of its destinations in roundabout ways and thus didn't compete by the clock because it couldn't. It made up for that with personal service that endeared it to many passengers who chose its slower trains intentionally.

The modern merger movement—which began in 1959 when Norfolk and Western took over the Virginian Railway—gradually unraveled all that. Suddenly weaker companies began to seek strong merger partners, and those strong partners sought chances to grow and survive against the other carriers.

B&O eventually was taken over by the Chesapeake and Ohio Railway on February 4, 1963. The following summer, several tunnels between Parkersburg and Clarksburg were enlarged or "daylighted" to accommodate higher and wider freight cars. The long months during which the line was closed created the impression in some minds that the affiliated companies could eventually do without it altogether. And so, on September 16, 1985, a scant year and a half before B&O's corporate identity was merged into successor CSX Transportation, an excursion train became the last train on the line.

Today much of the old right-of-way is a walking trail. Nikes and Nikons roam the hills and hollows where speeding streamliners and thundering steam locomotives once hauled the nation's commerce. Some of the other branch lines have been abandoned or leased to other companies, and photographers who admire railroads must be a bit more selective in finding places to aim their shutters.

This book takes a close look at the B&O's passenger and freight trains, locals, and structures in its halcyon days—and most importantly, its people, who endeared their company to generations of travelers, shippers, and the small Appalachian communities of West Virginia.

One

PASSENGERS

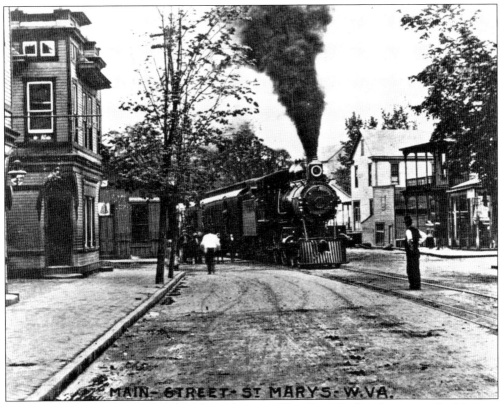

A southbound passenger train of B&O predecessor Ohio River Railroad pauses at St. Marys c. 1910. Smart little towns in the upper Ohio Valley such as this one, accustomed to the sonorous call of the steamboat, happily greeted the arrival of the faster and more convenient trains when they arrived in 1884. (Bob Withers collection.)

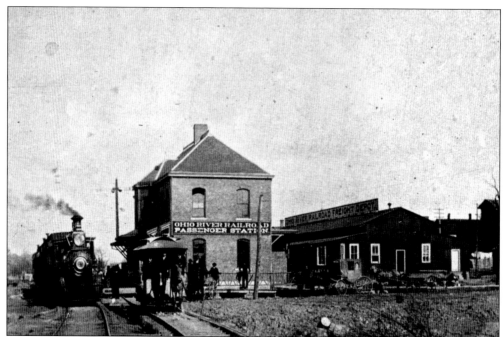

The Ohio River Railroad, building south from Wheeling, reached Huntington in 1892 when it took over the Huntington and Big Sandy Railroad. Here a horse-drawn streetcar prepares to take recently arrived passengers in that era to a connecting train at the Chesapeake and Ohio (C&O) Railway station across town. (Nancy Hirzel/Bob Withers collection.)

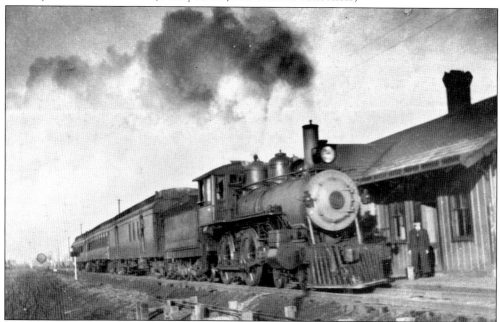

For several years before becoming part of Huntington, Central City was a separate municipality with its own railroad stations and yards. Here an eastbound Ohio River (OR) Railroad passenger train pauses at Central City in 1907. Five years later, the OR was destined to become part of the B&O. (Winnie Arthur/Bob Withers collection.)

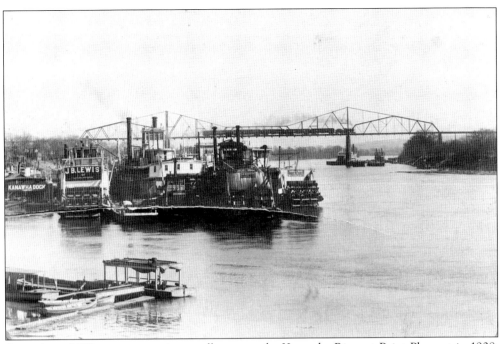

A westbound OR passenger train trundles across the Kanawha River at Point Pleasant in 1908. Steamers *E. R. Andrews* and *Robert P. Gilliam* are beyond the bridge, while tied up at the Kanawha dock are the *J. B. Lewis*, *Keystone State*, *Bonnie*, *J. Q. Dickinson*, and *Vernie Mac*. (Capt. Russell Stone/Bob Withers Collection.)

An eastbound train calls at Parkersburg's Sixth Street Station on the Baltimore–St. Louis main line *c.* 1915. A local waits behind the station, and a spare wooden coach awaits assignment in the right foreground. From the looks of the people milling around the trains, Parkersburg must have been a busy place indeed in those days. (O. S. Nock/Bob Withers collection.)

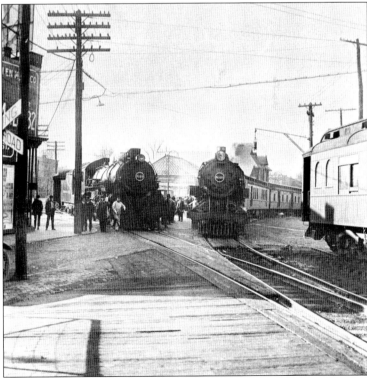

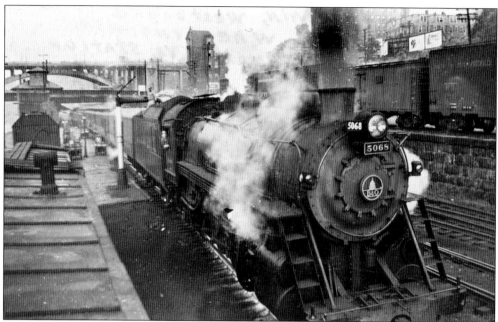

Fireman C. A. Clark, above, fills the locomotive's water tank as Train 43 stops at Fairmont at 7:20 a.m. in August 1948. The run was the last surviving passenger service on B&O's original main line between Grafton and Wheeling. Passengers from New York City, Philadelphia, Baltimore, and Washington made connection with it on Trains 3, the *Diplomat*, and 23, the *West Virginian*. Below, the same run, by now known as Train 343, exits Soles Tunnel just west of Hundred on Friday, May 1, 1953. The train includes a sleeping car—offering 10 open sections, two compartments, and a drawing room—to Wheeling that started its journey in Washington. (Both photographs O. V. Nelson/Bob Withers collection.)

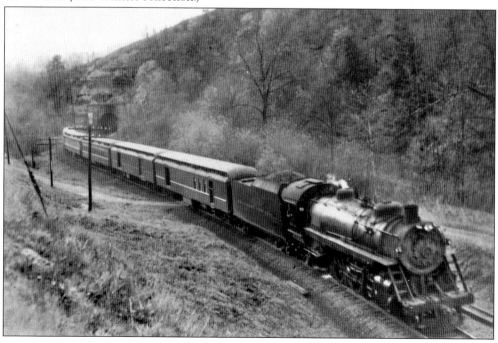

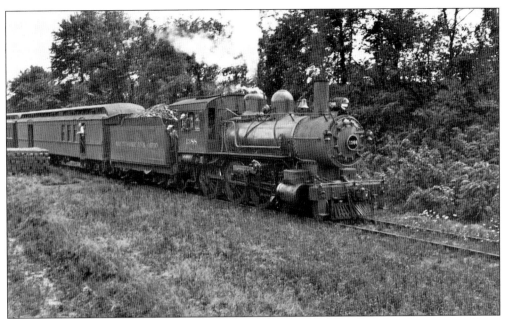

Kenova-Wheeling Train 72 stops at Graham on July 26, 1936. It actually is running as Train 720 because it is Sunday, and on that day it makes all the local's flag stops. Since the express car doesn't run on Sundays, the tiny 10-wheeler has only a baggage/mail car and coach in tow. The accommodating crew has allowed the photographer to disembark and snap the photograph. (Robert G. Lewis/Bob Withers collection.)

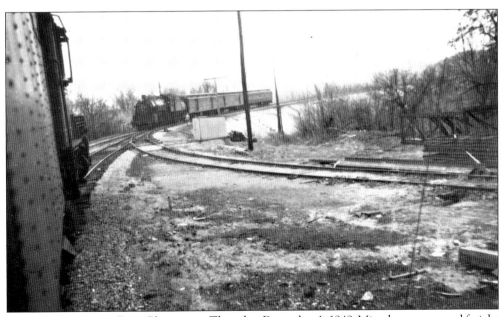

Train 72 is arriving at Point Pleasant on Thursday, December 1, 1949. Mixed passenger and freight Local Train 81, upon which the photographer is riding, is "in the hole" on a passing siding to allow the passenger train to hold the main line while it stops at the station. (John King collection.)

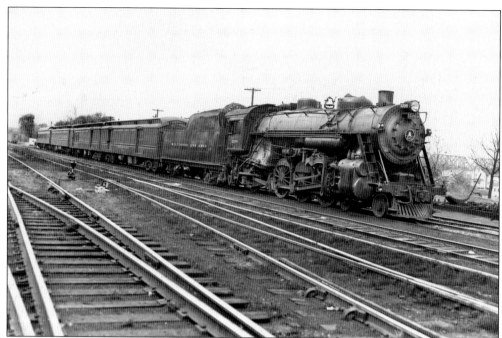

Overnight Train 78 is lined up at Kenova on Tuesday, November 6, 1951, with its customary locomotive, express car, baggage/mail car, coach, and 12-section drawing-room sleeper. Alas, the photograph was made to present as evidence for the company's first application to the West Virginia Public Service Commission to have it discontinued. (Charles Lemley/Bob Withers collection.)

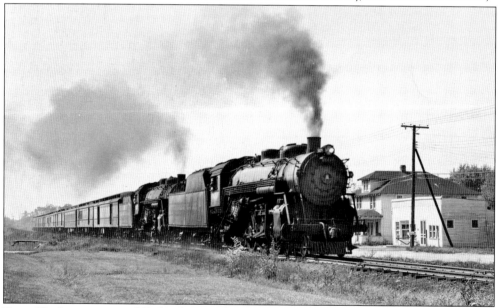

Train 72, chugging toward Parkersburg and Wheeling nearly a mile east of Guyandotte on the afternoon of Sunday, September 27, 1953, looks more impressive than it actually is. Normally a three-car train, 72's extra locomotive and six extra cars are deadheading back to Parkersburg after the final run of Overnight Train 77 was completed early that morning. (Charles Lemley/Bob Withers collection.)

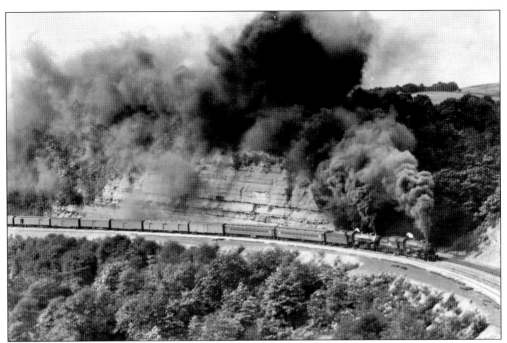

Two powerful locomotives struggle to lift Train 30's 12 cars—most of them carrying mail and express—up Cranberry Grade on Salt Lick Curve just west of Terra Alta at 10:27 a.m., Wednesday, September 29, 1948. All loaded freight trains and most of the passenger runs need helper engines in this territory. (Bruce Fales/Jay Williams collection.)

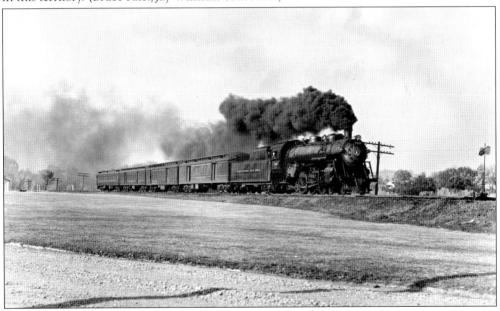

Train 73 is approaching RS&G Junction—the point at which B&O's Ohio River line connects with its Ravenswood, Spencer, and Glenville branch— after getting under way following its Ravenswood stop on Tuesday, October 23, 1951. Obviously environmental concerns are far in the future, as an inexperienced fireman makes plenty of black smoke to coat sheets hanging on local clotheslines with coal soot. (Richard J. Cook/Allen County, Ohio, Historical Society collection.)

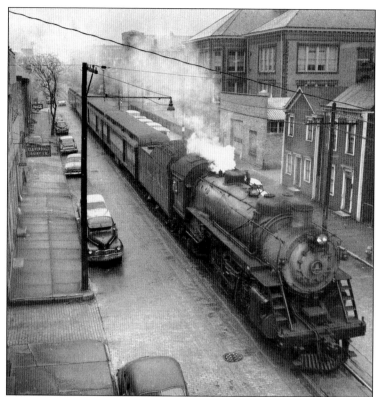

Wake up, Wheeling! Train 233 is chugging down the middle of Seventeenth Street en route to the station a block or so in the distance. Certain elementary students in the school building (right background) have been known to get in trouble with their teachers by standing on their chairs to see the morning train pass. (J. J. Young Jr./Bob Withers collection.)

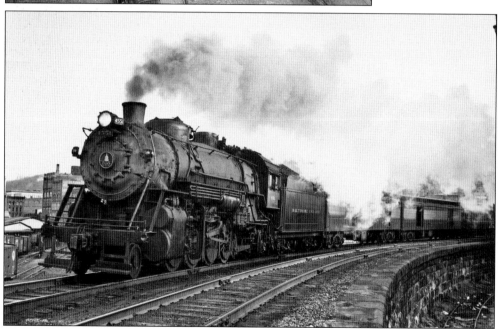

Train 233 departs Wheeling in November 1950 behind a freight engine. One would hope it is a warm day; after all, freight engines do not have steam lines to supply heat to the coaches. And it is a long way yet to Zanesville, Newark, Columbus, and Cincinnati. (J. J. Young Jr./Bob Withers collection.)

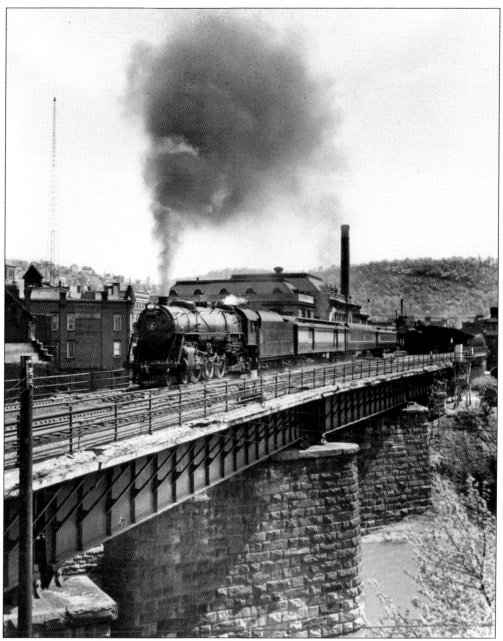

Train 233 departs Wheeling for Zanesville, Newark, Columbus, Cincinnati, and Louisville in May 1956. Passenger trains reached the elegant Wheeling passenger station on a four-track viaduct that spanned Wheeling Creek. Just five short years before, 14 trains arriving and departing from five different directions called there, more than any other B&O stop in West Virginia. But now Train 233 is less than three months away from extinction and has already lost its parlor/dining car. But at least one of the coaches offers reclining seats and a snack counter. On this day, the three-car train is being pulled by Pacific-style Locomotive 5300, the *President Washington*, which is preserved today at the Baltimore and Ohio Railroad Museum in Baltimore. Wheeling will lose its last pair of trains, to and from Chicago, all too soon in 1961. (J. J. Young Jr./Bob Withers collection.)

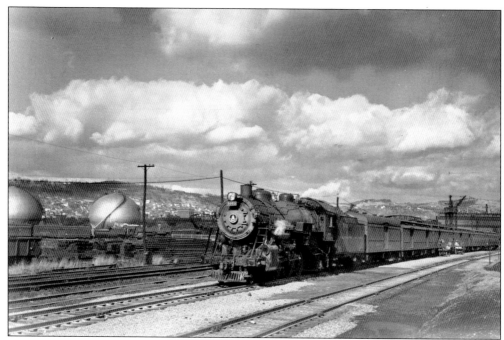

Wheeling-Kenova Train 73 makes a station stop at Benwood Junction, 4.4 miles south of Wheeling, in October 1947. Sharp eyes may detect two other passenger runs in the photograph—Train 46 from Chicago, at left, has crossed the bridge from Ohio and is taking the loop around to Wheeling, and just above 46, Train 33 can be seen on the bridge approaching Bellaire, Ohio. (J. J. Young Jr./Bob Withers collection.)

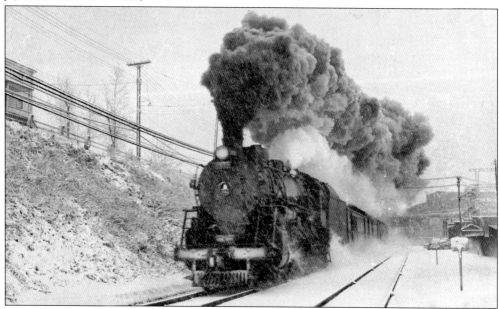

Northern West Virginia is battling the horrendous snowstorm of December 1950 as Grafton-Wheeling Train 430 passes the Wheeling Steel plant in Benwood near the completion of its trip. Before the storm abates, 39 inches of snow will blanket the region and delay—but not stop—the trains. (J. J. Young Jr./Bob Withers collection.)

B&O Train 33 arrives at Wheeling in the summer of 1952, but at the Pennsylvania Railroad (PRR) station instead of its own. A derailment at Bruceton, Pennsylvania, has forced the Pittsburgh-Cincinnati train to detour on the PRR via Weirton Junction. Back then, railroad passengers blocked by wrecks stayed on their detoured trains instead of having to climb onto buses. (J. J. Young Jr./Bob Withers collection.)

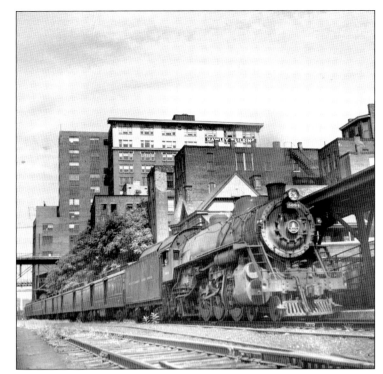

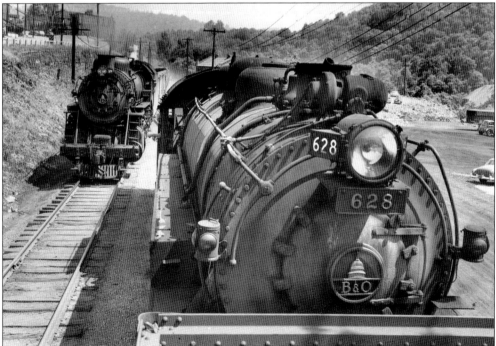

Yard Engine 628 switches cars about a mile east of the Wheeling station as Train 233 from Pittsburgh rolls by in August 1953. Wheeling Division superintendent J. J. Sell has noticed the photographer's unusually safe practices around trains and has granted him virtually unparalleled access to them. (J. J. Young Jr./Bob Withers collection.)

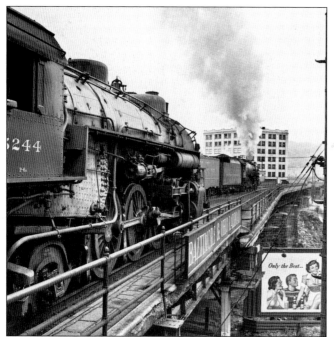

Train 233 departs Wheeling for Ohio points in February 1952 while connecting Train 73, bound for Parkersburg, Huntington, and Kenova, waits for its turn to leave. One wonders how many motorists driving down Market Street under the elevated tracks slowed down a little to watch the show up above. (J. J. Young Jr./Bob Withers collection.)

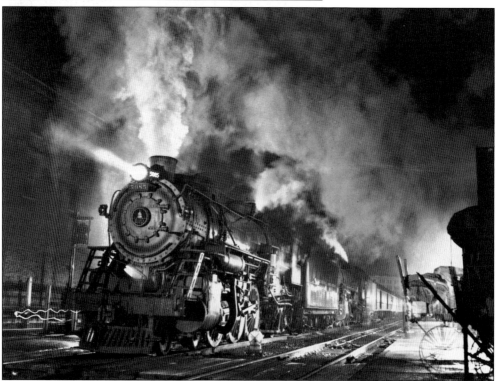

Wheeling's Christmas season is in full swing in 1952, and the extra mail and express cars on Train 238 requires two locomotives for the two-hour romp to Pittsburgh. The ghostly crewman and baggage cart at right and the zigzagging beam of light from a colleague's lantern at left are the result of a time exposure. (J. J. Young Jr./Bob Withers collection.)

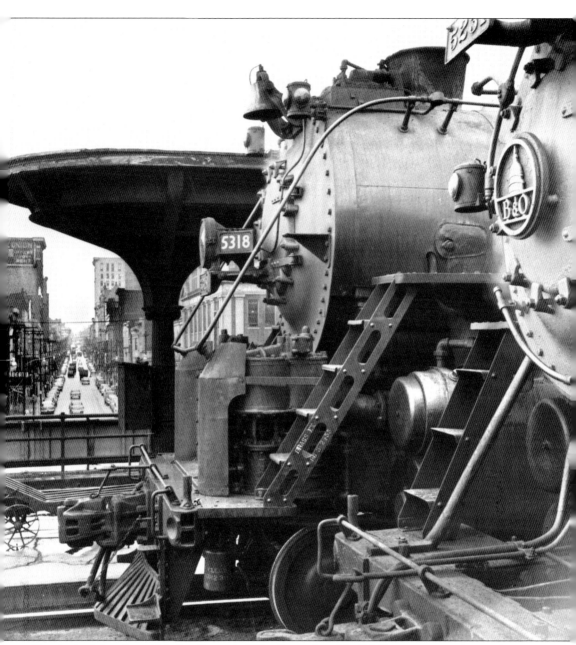

Here is the lofty view of Market Street in Wheeling enjoyed by B&O passenger engineers about to head west. This is late morning in December 1955, as Train 233 with Engine 5318 and Train 73 with Engine 5231 are ready to depart for Cincinnati and Kenova respectively. Not long after this photograph was made, Wheeling Division superintendent J. J. Sell, a greatly respected railroader's railroader, was booked by the city of Wheeling's overzealous smoke inspector because of all the coal-fired locomotives calling at the passenger station. Newspapers editorialized against the officer, and he was forced to apologize and back down. A few days later, a loyal yard crew found the smoke inspector's automobile slightly out of clearance near a switching lead and banged it up a bit before they got stopped. Sell threatened to have the fellow arrested for trespassing. (J. J. Young Jr./Bob Withers collection.)

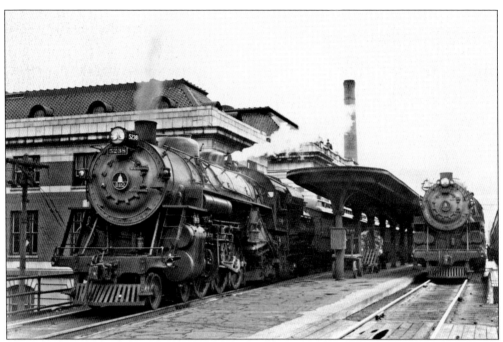

Here is another view of the morning train ritual that was performed for years at the Wheeling station. This time, Locomotive 5238, at the head end of Train 73, stands on the No. 1 track, while the Pittsburgh-Cincinnati Train 233, with Engine 5306, is spotted on the No. 2 track in the summer of 1955. (Charles W. Aurand/Bob Withers collection.)

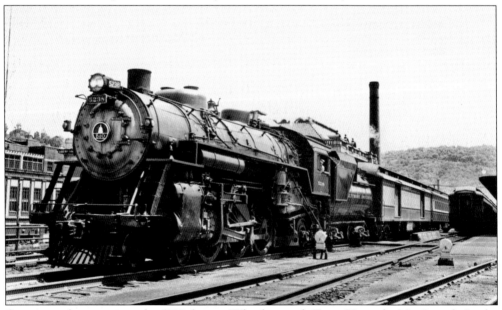

On yet another occasion, the 5238 departs Wheeling with Train 73 on the No. 2 track. In the distance on the No. 3 track, coaches from inbound Grafton-Wheeling Train 430 have yet to be put away in the coach yard. It is June 28, 1956, and the train from Pittsburgh, from which 73 likely has gained a few connecting passengers, has less than a month to live. (Charles W. Aurand/Bob Withers collection).

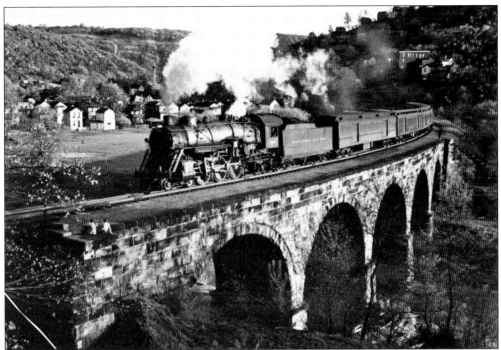

Train 72, Engine 5092, above, crosses the graceful stone viaduct in the Tunnel Green area of Wheeling in May 1950. The photographer lives within sight of this scene and was attracted to railroading at a young age. In fact, he skipped his surprise 11th birthday party for a cab ride with his B&O friends—much to the consternation of his parents. Below, a flood relief train passes the same spot two months earlier. For years, the B&O lent a helping hand when high water flooded roads but left the railroad rights-of-way high and dry. (Both photographs J. J. Young Jr./Bob Withers collection.)

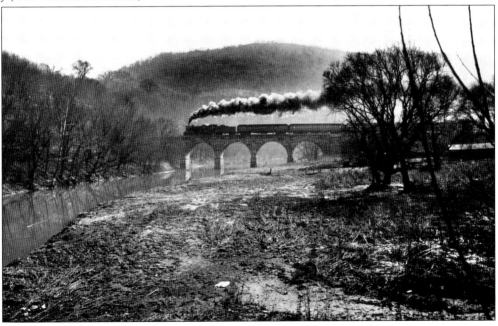

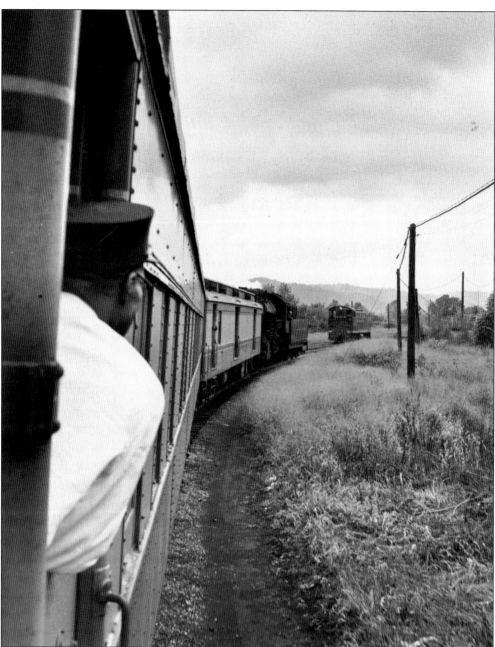

A weary sleeping car porter catches a breath of fresh air as a yard engine tows Train 246, arriving from Chicago, backward from Benwood Junction to Wheeling on a cool morning in October 1957. The West Virginia hills approached so close to the Ohio River at Benwood that architects had to design the railroad bridge with a curve toward the south to deliver trains to the north-south line to Wheeling. Trains bound for the Wheeling station came off the bridge heading south and had to negotiate a half-mile loop of track to head toward the north and the station. When they ran late, yard engines sometimes coupled onto their rear cars and dragged them backward into the station, avoiding an extra trip back to Benwood to turn the cars for their next outward movement. (J. J. Young Jr./Bob Withers collection.)

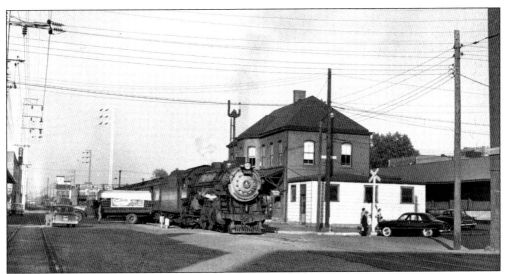

Train 73 pauses at the Huntington station on a sunny evening in May 1956. A Railway Express Agency driver prepares to unload packages from the express car as a single passenger—a grandfather, perhaps—walks with his family to their automobile to begin a delightful visit. We don't know about the old gentleman, but the train has less than a year to live. (Herbert H. Harwood Jr./Bob Withers collection.)

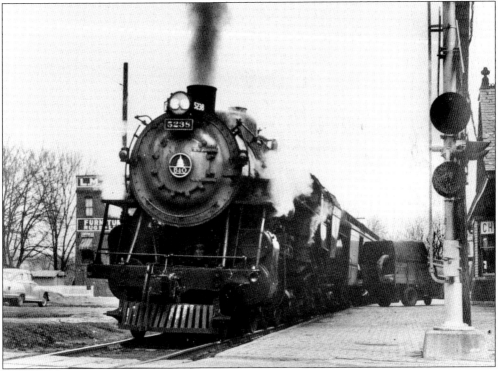

Railway Express Agency workers load a few packages onto Train 73 at Williamstown in January 1957, a few days before the last run. Agent/operator C. N. Dawkins dutifully recorded that on the final day, January 31, he sold a grand total of two tickets to Parkersburg, 12.6 miles away, for 51¢ each. (*Parkersburg News*/Bob Withers collection.)

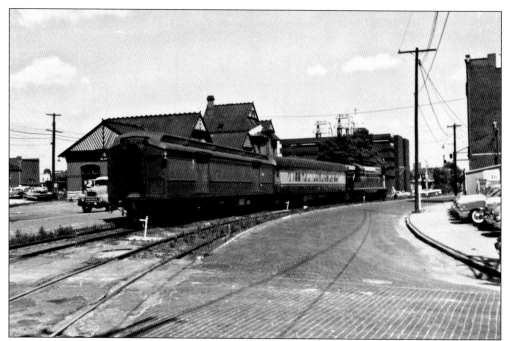

Train 23 is positioned at Parkersburg's Sixth Street Station for an 11:00 a.m. departure to Cincinnati on Wednesday, July 3, 1963. Other trains are being detoured between Parkersburg and Clarksburg during a massive tunnel-enlargement project, but 23's passengers have been bused from Clarksburg to resume their journey by rail on this short, nameless train. (Bob Withers.)

The westbound *National Limited*, Train 31, is running seven hours late as it calls at Parkersburg on a snowy Saturday morning, February 25, 1967. The previous day's 31 had wrecked at Toll Gate, killing four people (see page 87). Behind the sleeper/lounge/observation car is B&O Office Car 100, assigned to western regional manager A. W. Johnston. (Bob Withers.)

Two

FREIGHT

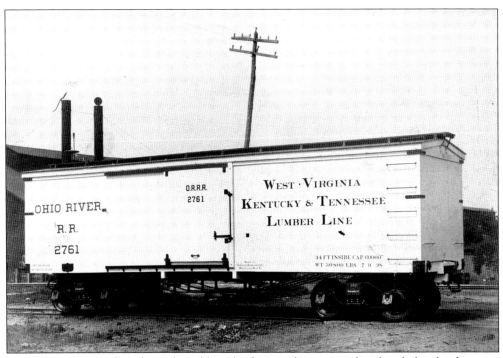

Passenger trains may have been the public's chief point of contact with railroads, but freight trains paid most of the bills. Even this tiny wooden boxcar, built by Ensign Manufacturing Company in Huntington on July 9, 1898, for B&O predecessor Ohio River Railroad, was a technological marvel in its day. (Collis P. Huntington Railroad Historical Society collection.)

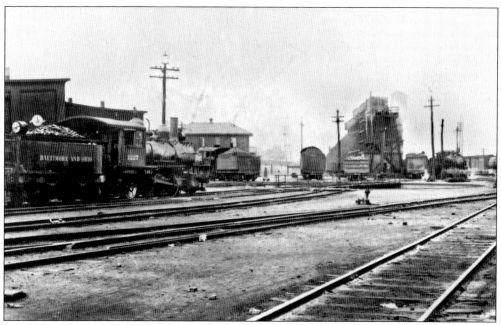

These views show the roundhouse, turntable, and shop area of B&O's Low Yard in Parkersburg *c.* 1915. When B&O predecessor North Western Virginia Railroad entered the city in 1857, crews laid its tracks in a generally east-west configuration. When the OR followed in 1884, its tracks were laid beside the company's namesake river in a north-south alignment—and passed under the main line's approach to the Ohio River bridge. Over time, the main line tracks became referred to as the "High Yard," while the OR tracks became the "Low Yard." Each yard boasted its own passenger station, and a transfer track connected them. (Both photographs John King collection.)

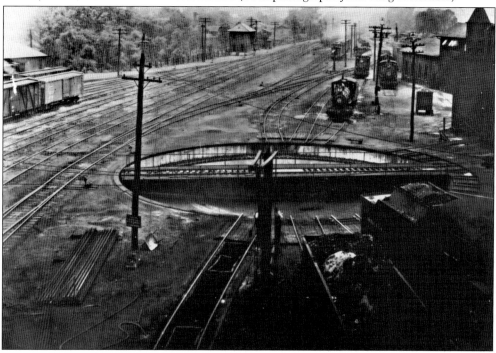

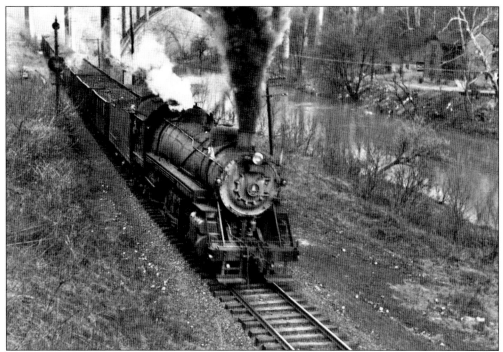

A 90-car train, above, passes under the U.S. 19 bridge and along an unusually high Buffalo Creek as it approaches Fairmont's yard with coal from the mines at Barrackville, Farmington, and Rachel. It is March 1948, and the locomotive is completing her first round trip after being rebuilt—a project in which the photographer, a shop employee, took part. Below, a Grafton-bound train proceeds through the first curve east of the Gaston Junction telegraph office on another line out of Fairmont on Tuesday, November 15, 1949. The images show that the dominant traffic in this region is coal. (Both photographs O. V. Nelson/Bob Withers collection.)

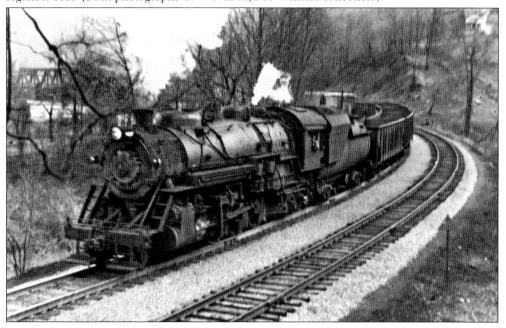

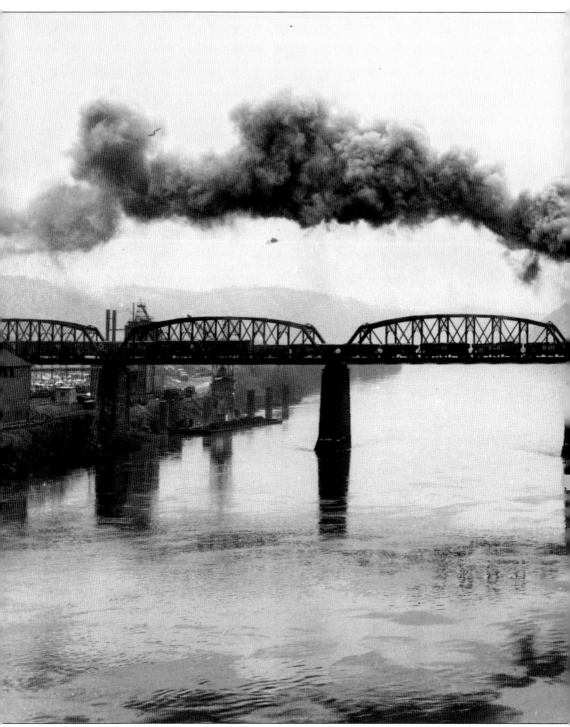

A mighty Class EM-1 articulated locomotive crosses the Ohio River bridge at Benwood Junction in March 1954 with another trainload of coal destined for the Lake Erie port of Lorain, Ohio. The 30 EM-1s were built by Baldwin Locomotive Works in 1944 and 1945—late for new steam—only because the government prohibited B&O from acquiring new diesel locomotives during World War

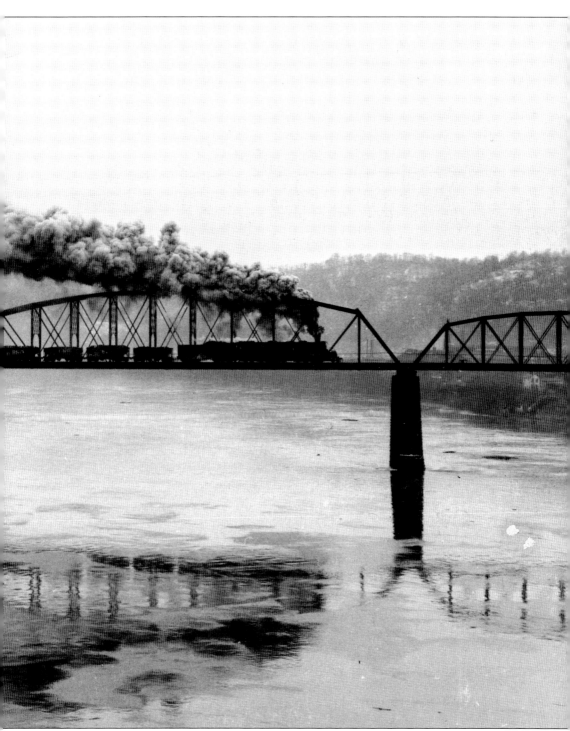

II. Equipped with superheaters, combustion chambers, siphons, feed water heaters, power reverse mechanisms, stokers, and roller bearings on all axles, they prompted B&O president Roy B. White to remark, "Well, I must say, they have everything." (J. J. Young Jr./Bob Withers collection.)

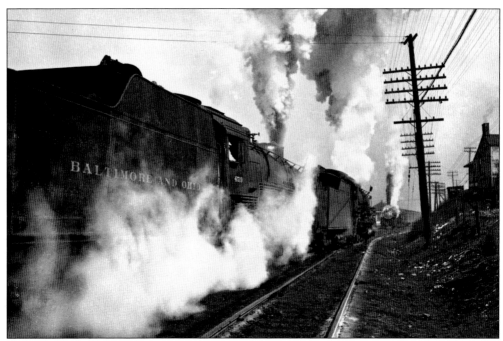

A doubleheaded freight train bound for Newark, Ohio, charges up the grade toward the Ohio River bridge at Benwood Junction in March 1948. Just ahead of the lead locomotive, sharp eyes can see Passenger Train 46 making its station stop following an overnight trip from Chicago. (J. J. Young Jr./Bob Withers collection.)

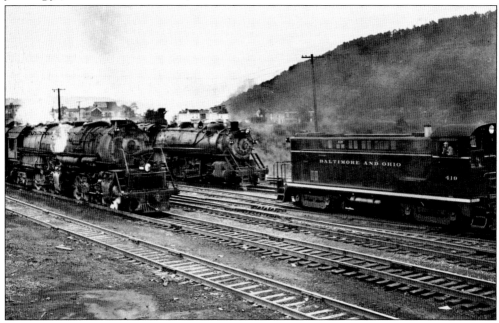

Steam locomotives wait for new assignments at the west end of the Benwood Junction yard in September 1955 as a relatively new diesel switcher works between them. These are days of motive power transition on the B&O; within three years, the steam will be gone. (J. J. Young Jr./Bob Withers collection.)

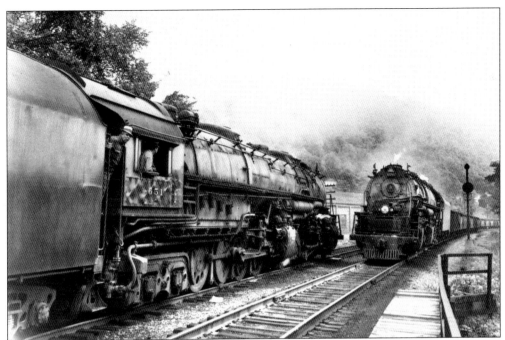

A Fairmonter and a Benwooder meet at SW Tower in McMechen in August 1957. Engine 651, left, with empties heading for the mines of central West Virginia, waits while Engine 670 crosses over to the other track with loads. Standing in the 651's gangway is road foreman of engines A. K. Jacobs. (J. J. Young Jr./Bob Withers collection.)

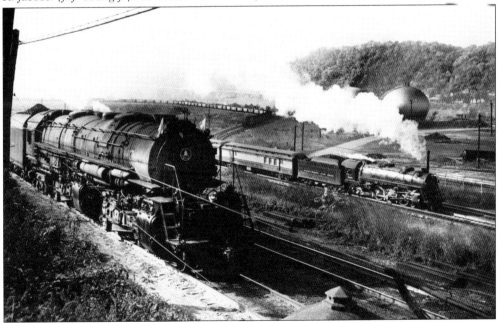

Benwood Junction is busy on a warm summer morning in August 1956. A coal train at left waits for a bridge and building gang to clear up on the Ohio River bridge, Passenger Train 430 begins the last lap of its romp from Grafton to Wheeling, and a diesel-powered mine run to Elm Grove waits for the passenger train to get by so it can proceed. (J. J. Young Jr./Bob Withers collection.)

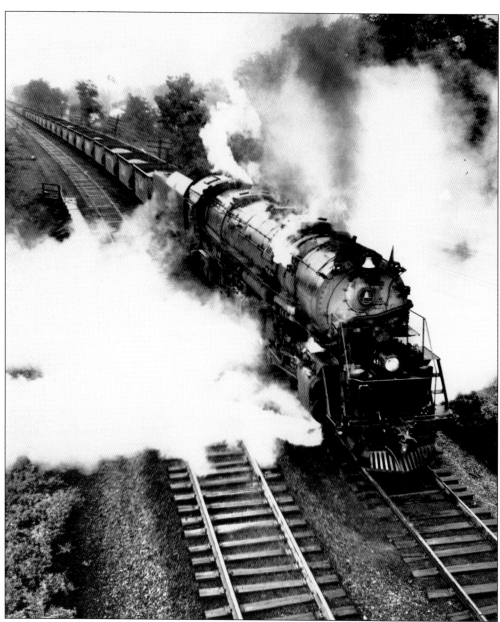

Class EM-1 Locomotive 651 gets a Fairmonter out of McMechen in a driving rain in August 1957. Originally assigned the 7600–7629 number series, these powerful locomotives—the finest and most powerful steam power B&O ever owned—were renumbered in the 650–679 series in early 1957 to keep them away from the four-digit numbers being assigned to the ever-increasing number of diesels. One of the EM-1s was supposed to be saved for the Baltimore and Ohio Railroad Museum in Baltimore, but through some sort of bureaucratic bungle, all 30 of them were scrapped. Comparing this image with the one at the top of page 33, it is likely the photographer snapped this photograph on the same day, after the loaded train in the other picture had proceeded into the yard at Benwood Junction. It also appears that, for this shot, he was standing on the high-pole signal visible in the other view. What amazing access he had to railroad property! (J. J. Young Jr./Bob Withers collection.)

A Class EM-1 locomotive, left, pushes a "humper"—a heavy train so named because it must travel over several hills, or humps—out of Benwood Junction as it begins its arduous journey over a sawtooth profile to Holloway, Ohio, in June 1957, while the crew on a smaller locomotive at right prepares to depart with Freight Train 99 for Parkersburg. (J. J. Young Jr./Bob Withers collection.)

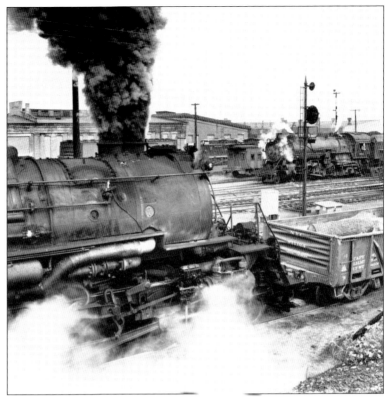

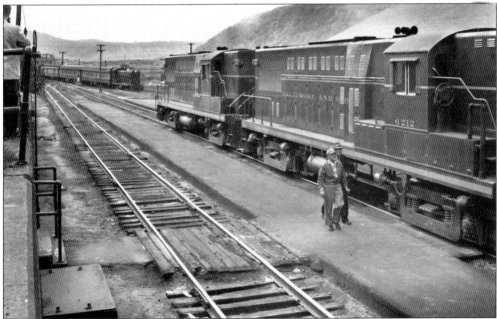

An inbound diesel-powered freight train cuts off high-level pedestrian access to the Benwood Junction passenger station while it waits for a yard engine to drag Chicago-Wheeling Train 246 four and a half miles up the river to the Wheeling station in September 1958. Steam is gone from the area now; diesels reign supreme. (J. J. Young Jr./Bob Withers collection.)

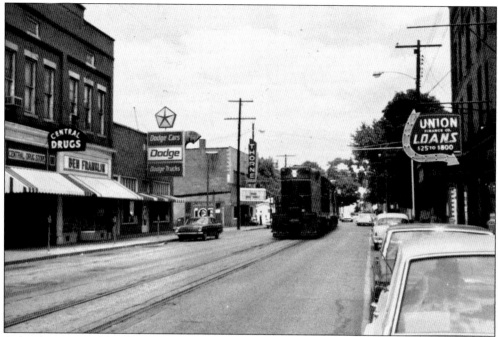

A freight train ambles down the middle of Second Street in St. Marys in the early 1960s. The main line of CSX Transportation's Ohio River Subdivision still runs down the middle of the thoroughfare. Motorists have discovered the hard way that there is not enough room on the hill side of the track for a vehicle to operate between the rails and the line of parked cars. (Bob Withers collection.)

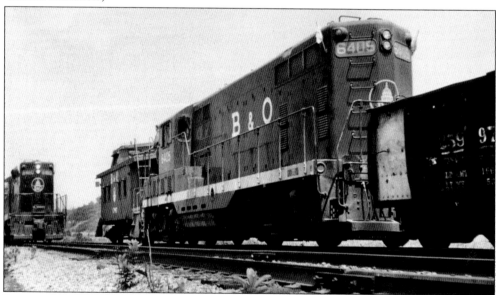

Engineer Joseph R. Krupinski, operating a work train assigned to pick up old rail, stands outside his locomotive to watch the Kaiser district run go by the siding at Polk on Monday, July 25, 1966. The latter train is running a dedicated service to the Kaiser Aluminum plant near Ravenswood. The author is Krupinski's head brakeman, and he has pulled out his camera to record the meet. (Bob Withers.)

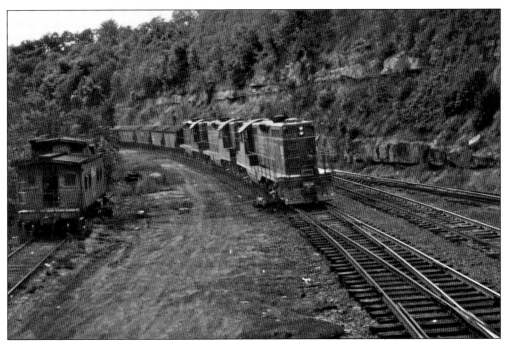

A mine run that has been gathering 76 loads of coal from tipples in the Wilsonburg area returns to Clarksburg at 3:37 p.m. on Wednesday, July 3, 1963. B&O crews who were based in Clarksburg collected coal from mines located on tracks radiating in five directions from the city. (Bob Withers.)

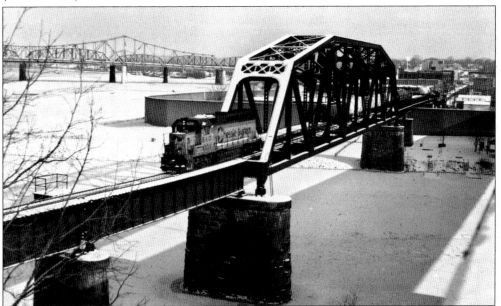

The DuPont district run—with its locomotive dressed in the new, colorful Chessie System livery—crosses the Little Kanawha River at Parkersburg in the mid-1970s. The crew must travel only seven miles to the old flag stop of Washington along the Ohio River (at left) but will spend virtually its entire tour of duty switching freight cars at several industrial plants that have grown up around DuPont. (Bob Withers collection.)

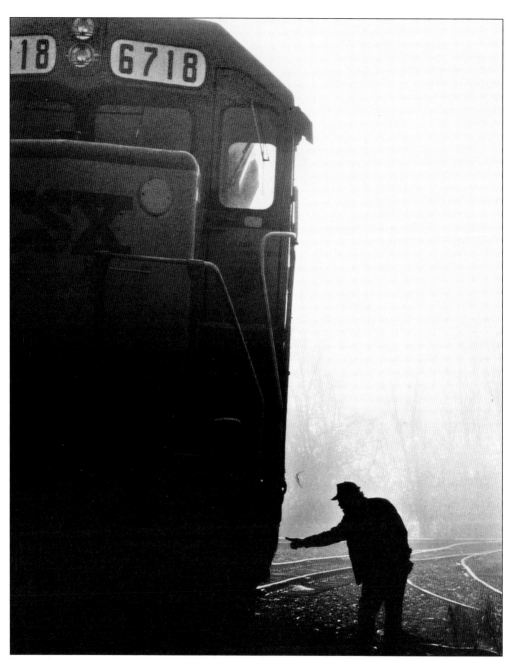

There are several tasks engineer Lee Boyce must do before the Point Pleasant district run can leave town on the foggy morning of Monday, February 20, 1995. Number one is feed the stray cat that lives under the station platform. Number two, shown here, is to check the fuel gauge on CSX Transportation Diesel 6718. Before the day is over, Boyce and his crewmates will switch cars in and out of the Conrail interchange tracks at Point Pleasant, the Akzo-Nobel plant at Gallipolis Ferry, and the Shell Chemical Company plant at Apple Grove. Midway through the day, brakeman Fred Lewis will cook some succulent beans on the caboose stove and persuade Boyce to develop a little "air trouble" at Gallipolis Ferry so they can stop at the Cracker Box Grocery for a minute and buy some butter for the rolls. (The *Herald-Dispatch*/Bob Withers collection.)

Three

LOCALS

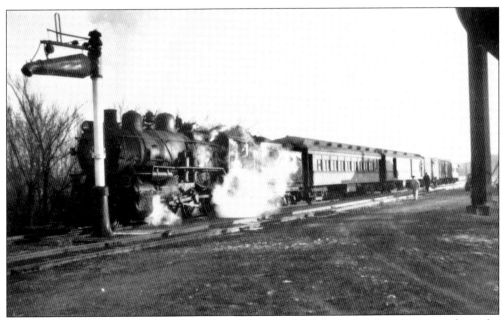

Locals enjoyed less stature than through passenger and freight trains, but they carried a wider variety of goods. Some, such as Train 81, calling at Millwood in December 1949, hauled passengers, mail, express, less-than-carload shipments, and a few carloads of materials to and from the lesser flag stops. (John King collection.)

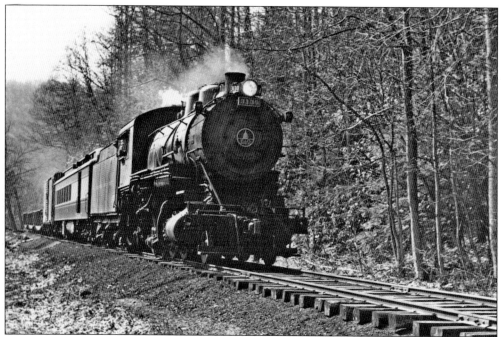

Train 453 from Buckhannon to Pickens carried no mail in the 1950s but maybe a few passengers and a package or two of express in addition to its freight cars. It hung on longer than many mixed trains, being needed to haul schoolchildren living in the remote hills and hollows to and from school in Buckhannon. (Bob Withers collection.)

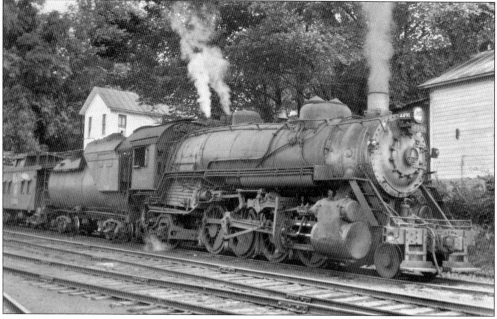

Not all locals hauled passengers, freight, and express. Since many stops were made and much switching was necessary, the railroad thoughtfully provided a second caboose right behind the locomotive to accommodate the conductor and head brakeman. Here Train 87 calls at St. Marys on Friday, August 3, 1956. (Dan Finfrock/Bob Withers collection.)

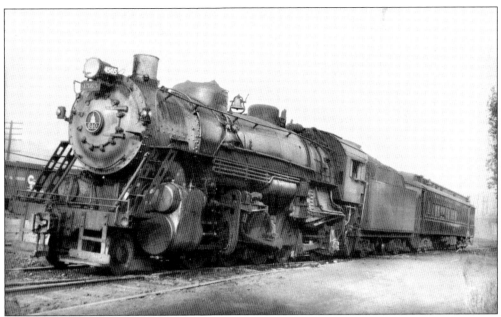

During most of its sunset years, Local Train 82 consisted only of a locomotive and combination passenger/baggage coach for its first eight miles from Kenova to Huntington. After making the station stop at Huntington, the crew picked up its freight in the Huntington yard for the remainder of the trip to Parkersburg. Here Train 82 is ready to leave Kenova on Tuesday, August 28, 1956. (TLC Publishing, Inc./Bob Withers collection.)

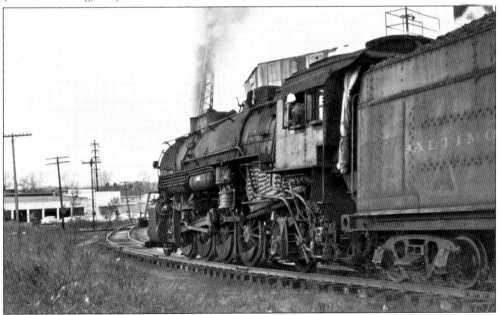

Train 81's fireman leans out of his window as his train passes the Standard Ultramarine and Color Company plant in Huntington and approaches a crossing with the C&O's Belt Line in the summer of 1955. The paddle on the tilting target signal—not to be confused with nearby telephone poles—must be at the horizontal position for B&O trains to proceed. (Gary E. Huddleston/Bob Withers collection.)

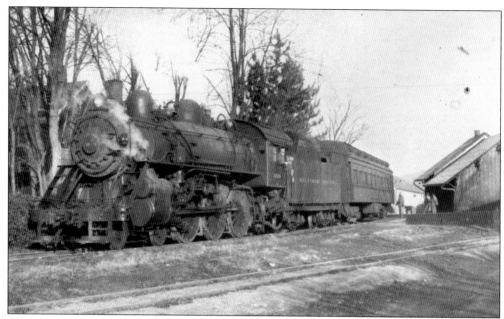

These views show the mixed train that served Ripley, a barn-like station that stood at the end of a 12.3-mile branch from Millwood. Above is Train 961, arriving on Thursday, December 1, 1949. Below is Train 962, ready to depart on Wednesday, October 24, 1951. The locomotive has been turned on a nearby turntable operated by compressed air. Retired engineer James R. "Monty" Montgomery says that sometimes the mechanism ran out of air with the engine only half turned. At those times, the crews relied on an accommodating farmer and his tractor to finish the job. (Above, John King collection; below, Richard J. Cook/Allen County, Ohio, Historical Society collection.)

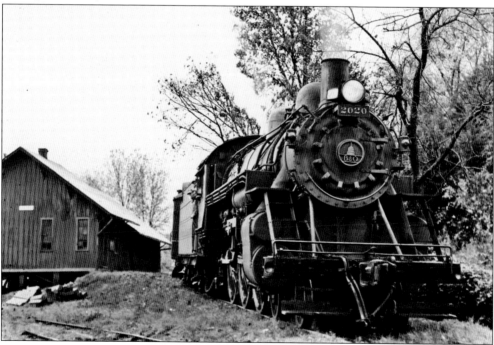

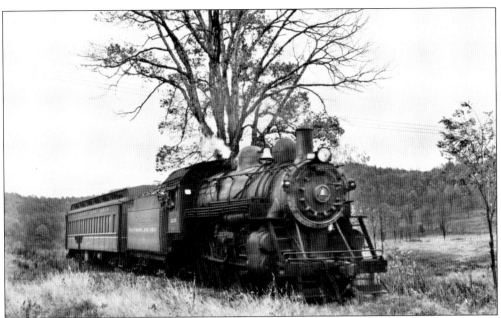

Train 962, above, has departed Ripley on Wednesday, October 24, 1951, and is passing Evans on track overgrown with weeds on its way back to Millwood. There the engine and coach will resume their duties on the Ohio River line, advancing Train 81 to Kenova. Below, Train 961 arrives at Ripley on Thursday, December 17, 1953—the first day a diesel locomotive plied the branch. Posing for the occasion are, from left to right, engineer Vic Davis, fireman James R. "Monty" Montgomery, Eastern Region supervisor of locomotive operations D. J. Ferrell, conductor Tommy Thompson, and retired Ripley agent C. E. Flesher. Henceforth, the Ravenswood–Spencer crew also will work the Millwood–Ripley branch, and Train 81 will proceed along the Ohio River without making the detour to Ripley. (Above, Richard J. Cook/Allen County, Ohio, Historical Society collection; below, Don Flesher/Bob Withers collection.)

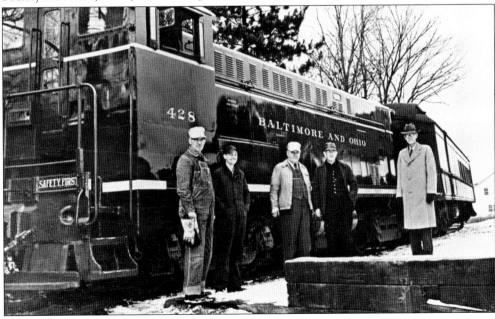

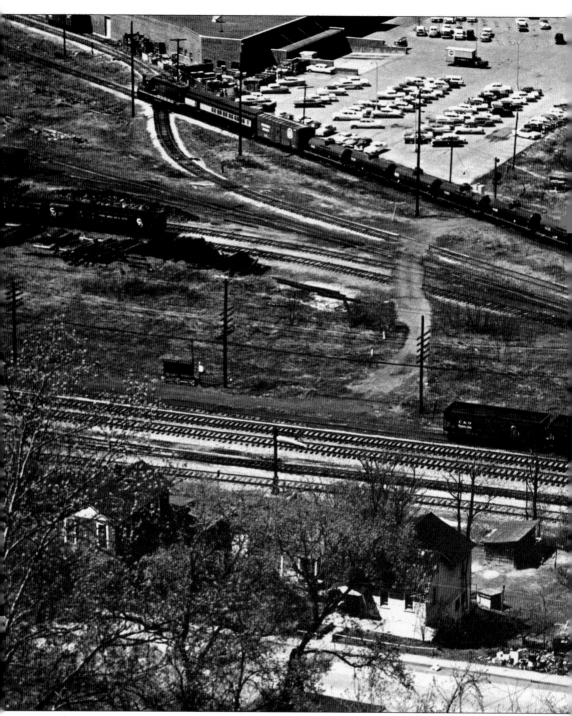

In the summer of 1960, the photographer has found a fantastic perch in Rotary Park to capture the entire consist of Local Train 81 as it enters Huntington. Behind the diesel are the passenger/baggage coach, 11 freight cars, and the caboose. Trains 81 and 82 became mixed passenger and freight operations in 1932, when B&O received permission from the West Virginia Public Service Commission to drop a pair of passenger trains. After the local made its last trip on Saturday,

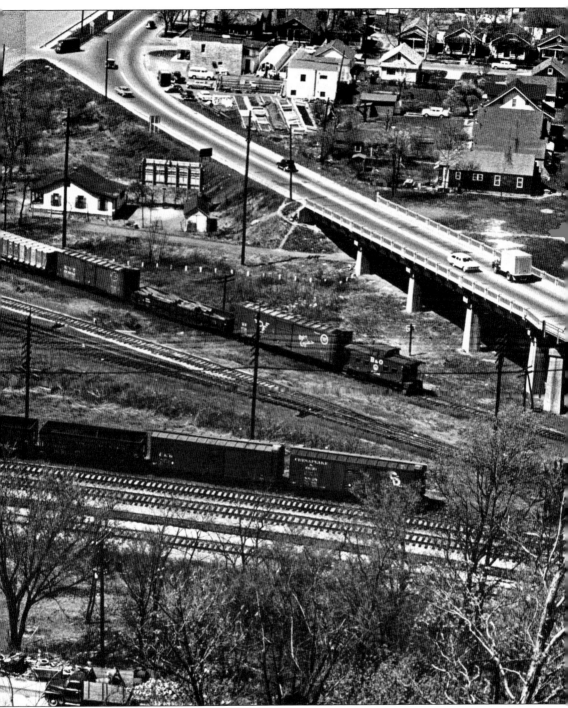

October 8, 1960, the combine was transferred to overnight Freights 92 and 93. Crews complained about having to see around the big coach while switching cars, and in December, passengers began to be hauled in the caboose—a service that endured with B&O's grudging compliance—until the advent of Amtrak on May 1, 1971. (John P. Killoran/Bob Withers collection.)

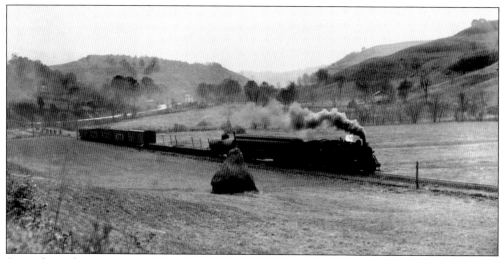

Since the author is sentimental and a bit old-fashioned, he does not like to talk about diesels and train discontinuances all that much. So enjoy a photographic tour along the Ravenswood-Spencer branch on this and the next six pages in better times, with most of the images taken on the same day. Above, on Tuesday, October 23, 1951, Train 458 passes a single haystack out of Spencer. Note that the train carries no caboose; it is the only train on the line, and there is no need for the flagman to ride back there by himself. Below, baggagemaster Charles Shank reboards the train at Reedy alone. No passengers will board here today. (Both photographs Richard J. Cook/Allen County, Ohio, Historical Society collection.)

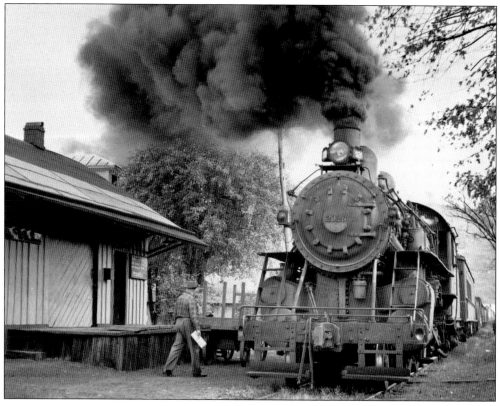

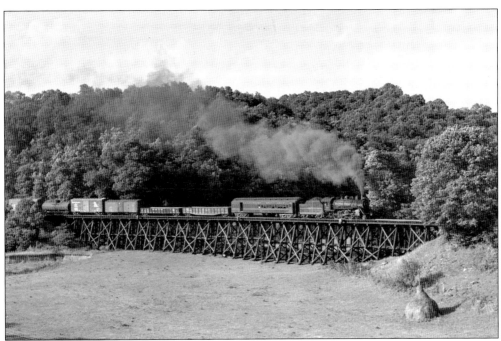

Here Train 458 rumbles across Barrs trestle on Thursday, June 26, 1952, heading toward Ravenswood with its coach and nine cars. Above, Engine 2026 pulls, and below, Engine 2020 pushes. The RS&G Subdivision—Ravenswood, Spencer, and Glenville, although the line never was built from Spencer to Glenville—traversed three steep grades that required two engines if crews had any tonnage at all to move. The line also boasted of 69 wooden-pile trestles—some of them high and gigantic, others spanning a thimbleful of water—in its 32.7 miles. (Both photographs Richard J. Cook/Allen County, Ohio, Historical Society collection.)

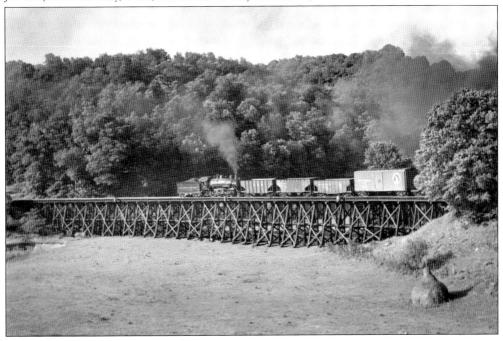

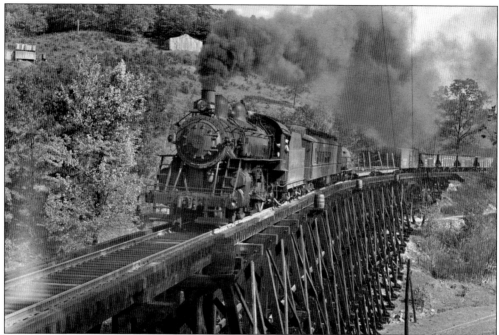

On Tuesday, October 23, 1951, Train 458 Engine 2026 (above) loafs down a steep 2.96-percent grade as it crosses a trestle just past Sandy Summit. The middle-of-nowhere spot boasted one of the more spectacular trestles on the line, and once railroad enthusiasts discovered it, they sometimes persuaded crews to carry them across, let them disembark in a cow pasture, back up, cross the span again for the benefit of their cameras, and pick them up again. Later, below, flagman "Curly" Clark (left) and baggage master Charles Shank once again oblige a photographer by halting for a pose while loading a farmer's can of cream into the coach's express/baggage section. (Both photographs Richard J. Cook/Allen County, Ohio, Historical Society collection.)

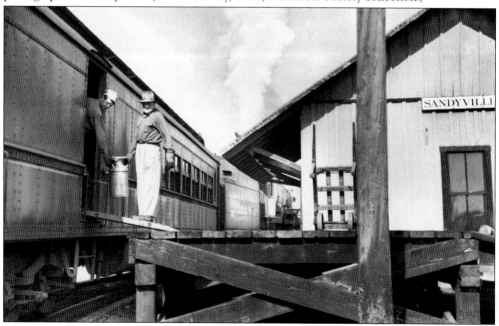

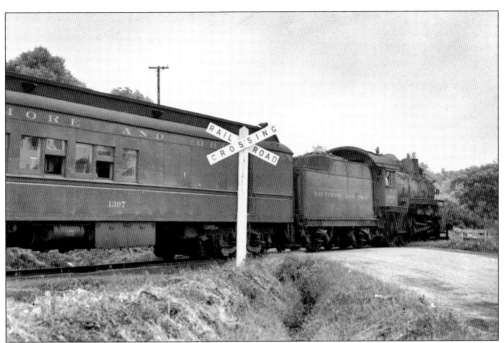

On Saturday, June 10, 1950, Train 458 departs Sandyville, once again with two tiny 10-wheeler locomotives. Class B-18d Engine 2026, above, pulls the train, while Class B-8 1396 shoves. The 1396 will be off the company's roster by the end of the year, and the 2026 has less than four years to operate. "It really took one back to the 1920s," the photographer wrote to the author several years ago. "It gave the appearance of a way of life that would never end. Of course, I knew better." (Both photographs Richard J. Cook/Allen County, Ohio, Historical Society collection.)

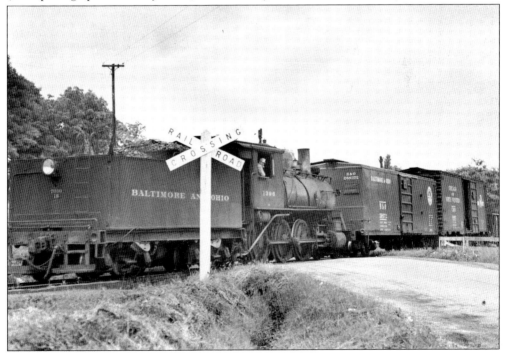

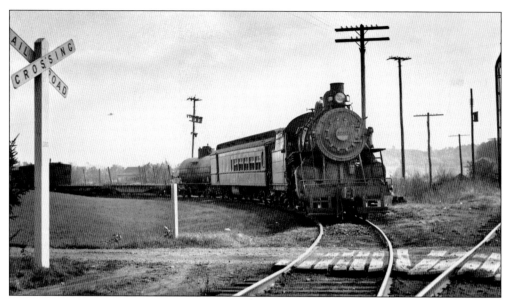

Return again to Tuesday, October 23, 1951. Above, Train 458 heads around the east leg of the wye—a Y-shaped track arrangement that permits the turning of locomotives—at RS&G Junction, where the RS&G line ties into B&O's Wheeling-Kenova Ohio River line. Below, the locomotive clatters through the switch while baggage master Charles Shank waits for the train to pass so he can realign the switch for the main line. The crew will trundle on to Ravenswood, another half-mile, where they will unload passengers and express and deliver freight cars to sidings to be picked up by through trains. Later that afternoon, they will retrace their steps back to Spencer. (Both photographs Richard J. Cook/Allen County, Ohio, Historical Society collection.)

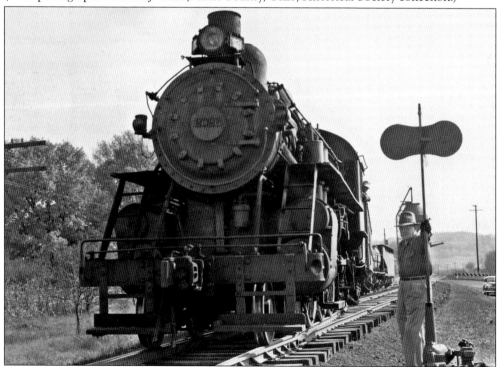

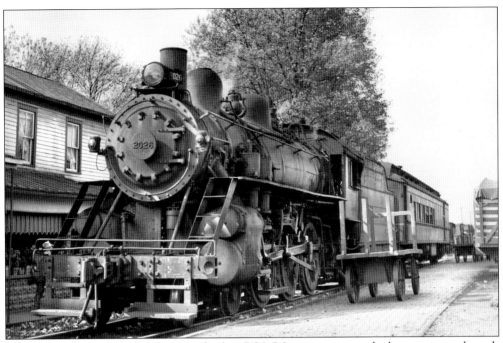

"Later" has arrived. The crew has gone back to RS&G Junction to turn the locomotive and coach and fill the tender's bunker with coal and has backed into Ravenswood to fill the engine's tank with water. Passengers going beyond Ravenswood have connected with Trains 72 and 73, and a new load of express—note the empty cream cans—must be loaded for the return to Spencer. Above, the locomotive sits at the station with an old hotel in the background. Below, on the station side, agent Pete Dowell, in the necktie, chats with a local train watcher. Note the coach's open windows; in the winter it was heated by a coal stove, and on warm days, one's access to air conditioning depended on one's ability to raise the sometimes-stubborn windows. (Both photographs Richard J. Cook/Allen County, Ohio, Historical Society collection.)

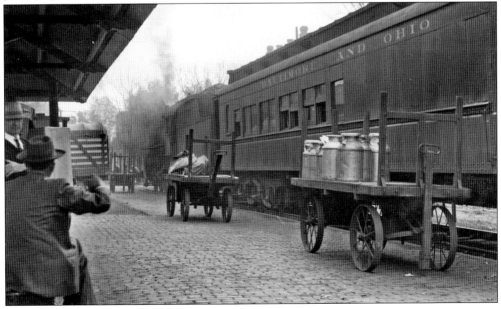

The Collis P. Huntington Railroad Historical Society, Inc., discovered the RS&G branch soon after its formation, and members rode the train in 1960, 1961, and 1962. With the advent of diesels, the train's schedule was turned on its head, starting the crew's day in Ravenswood, so the same locomotive could be used later in the day on the trip to Millwood and Ripley. Above, seen in the coach on Saturday, April 29, 1961, are, from left to right, Harlan Odell, flagman Art Buckley, conductor Pete Young, baggage master Glen Yost (partially hidden by Young), Malcolm Henderson, Mike Sellards, and Jack Waldeck. Below, Yost fills the stove with coal so everyone—including Henderson, behind him—will stay cozy warm. Later that year, the coach will be demolished by a runaway truck at Sandyville, and next year's trip will be in a caboose. (Bob Withers collection.)

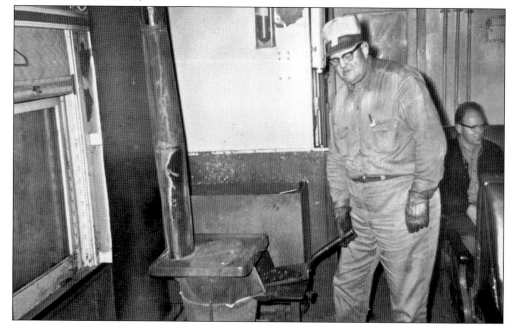

Four

LOCOMOTIVES

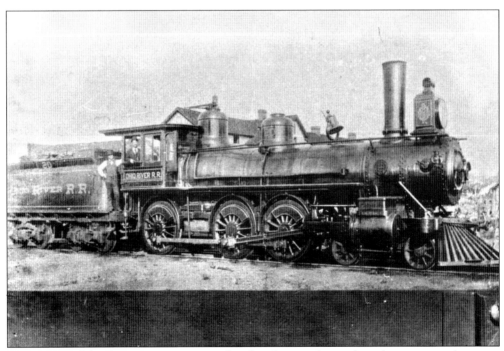

Passengers and freight are important to railroads, of course, but without locomotives, the trains don't roll. Here is 10-wheeler No. 20 of B&O predecessor Ohio River Railroad posing with engineer M. Elmer Withee, seated in the cab, and fireman R. U. Cariens in Parkersburg in 1891. B&O took control of the OR in 1901 and obtained the property outright in 1912. (Harold Wetherall/Bob Withers collection.)

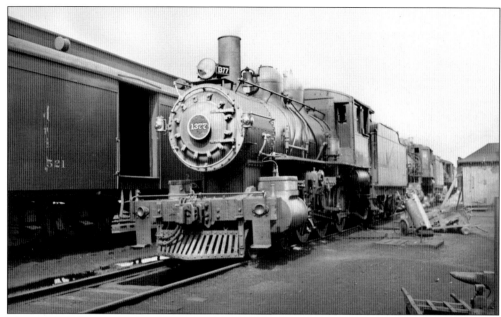

These tiny, light 10-wheelers built by Baldwin Locomotive Works in 1893 hauled fast passenger trains at one time, but they lasted far past their prime on the Parkersburg-Kenova line because of an outdated and dangerous bridge across the Kanawha River at Point Pleasant. Above is the 1377 between assignments at the Kenova engine shop on Sunday, July 26, 1936. Below is the 1383 in the late 1940s at the Parkersburg roundhouse. The latter locomotive has been completely rebuilt and is known locally as the "queen of the fleet." Both locomotives will be removed from service by 1951. (Above, Robert G. Lewis; below, Harold Wetherall/Bob Withers collection.)

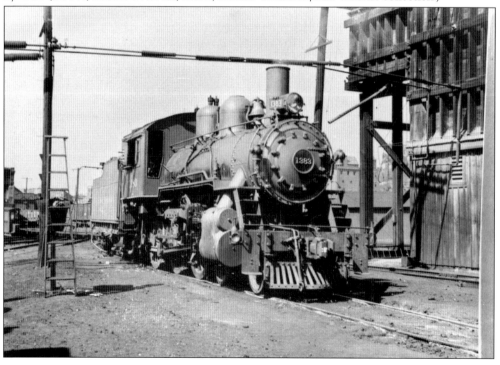

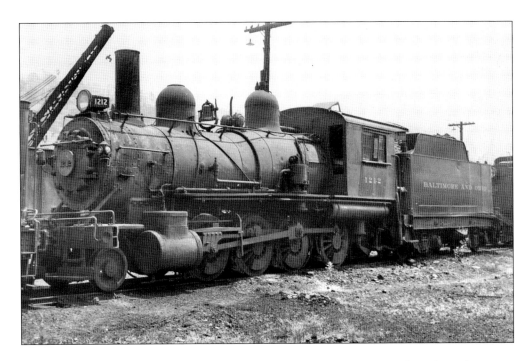

Examples of the tiny freight engines that held sway on B&O's main lines early in the 20th century are these Consolidation-type 1200s, but they, too, were bumped to branch-line service as the motive power department developed or purchased larger and heavier steam power. The 1212 above, built in 1892, rests between assignments at Gassaway in June 1940. Below is the 1234, built in 1893, resting under steam in Parkersburg on Sunday, July 26, 1936. Many of these engines spent their declining years also being used as yard power in outlying terminals. (Above, Harold K. Vollrath; below, Robert G. Lewis/Bob Withers collection.)

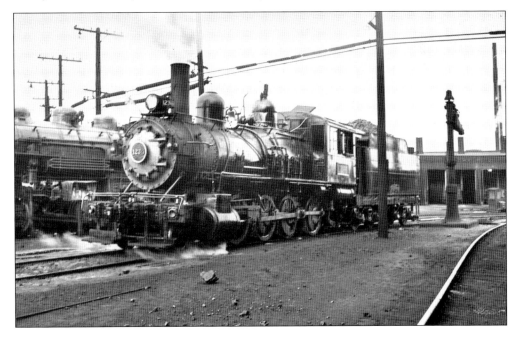

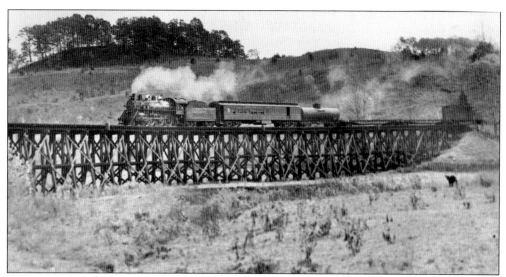

Ten-wheelers were the last steam power used on B&O branch lines between Ravenswood and Spencer and between Millwood and Ripley; fortunately the photographer chronicled much of their work in the early 1950s. The two images on this page record Class B-18d No. 2026 on a pile trestle near Reedy, above, on Tuesday, October 23, 1951, and below a little later in the day at Ravenswood taking water for the return to Spencer. The 32.7-mile branch served mostly agrarian interests, and a single mixed train—one passenger/baggage coach, with freight cars following—was sufficient to handle the traffic. The locomotives were built originally to haul fast passenger trains over the company's mountainous main lines, but they were bumped to the branches in 1949 and lasted in service until December 1953. (Both photographs Richard J. Cook/Allen County, Ohio, Historical Society collection.)

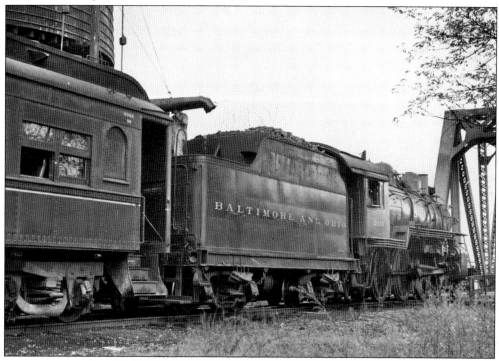

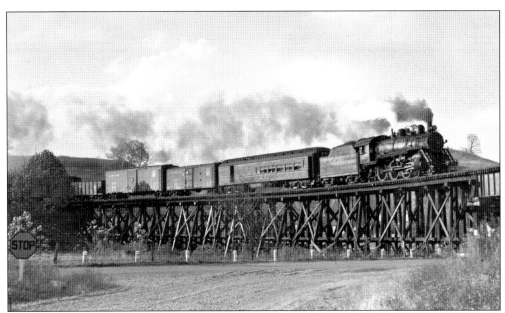

The photograph above shows another view of the 2026 crossing the Crow Summit trestle on the way back to Spencer. Fortunately the photographer found a place to spend the night, because on Wednesday, October 24, 1951, he caught up with sister engine 2020, below, on mixed Train 81 at Mason City, nearly 30 miles below Ravenswood on the Ohio River line. The 10-wheelers were used on the river line's Trains 81 and 82 because the westbound ducked into a siding at Millwood six mornings a week, uncoupled the coach, and went out to Ripley and back as Trains 961 and 962 before continuing to Kenova. That gave passengers 24 more grimy miles of ride for their money, but made for some late arrivals at the end of the line. (Both photographs Richard J. Cook/Allen County, Ohio, Historical Society collection.)

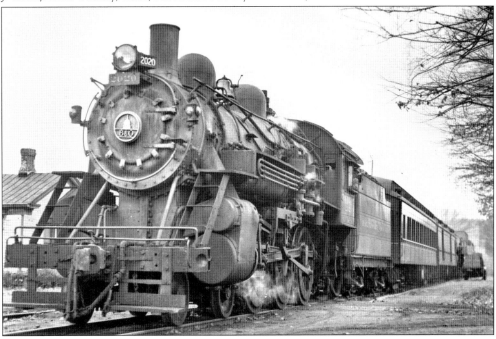

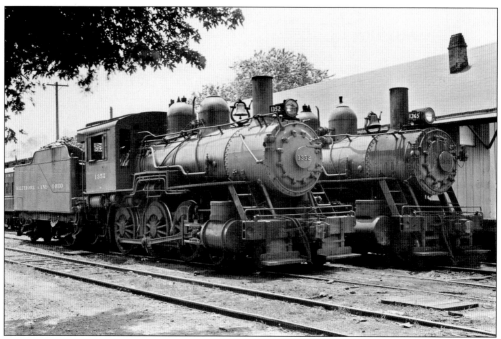

Here two Class B-8 10-wheelers rest at Spencer on Sunday, June 5, 1949. Trains on the RS&G branch often were doubleheaded—even with short trains—because of three horrendous grades that at the outset prevented the branch from ever being a lucrative high-tonnage artery. (Richard J. Cook/Allen County, Ohio, Historical Society collection.)

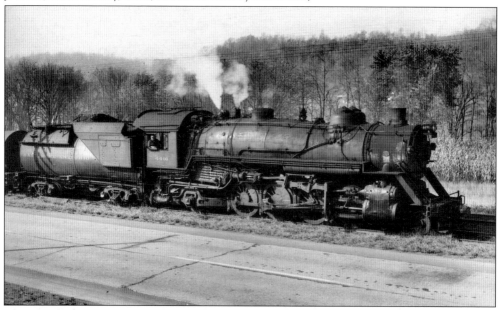

This chunky locomotive, pulling Train 98 near St. Marys in 1956, was built in 1922. She and her sisters were known on most railroads as the Mikado type, but B&O began calling them MacArthurs in World War II because of the battlefield heroics of Gen. Douglas MacArthur and the reluctance to recognize anything Japanese. (Richard J. Cook/Allen County, Ohio, Historical Society collection.)

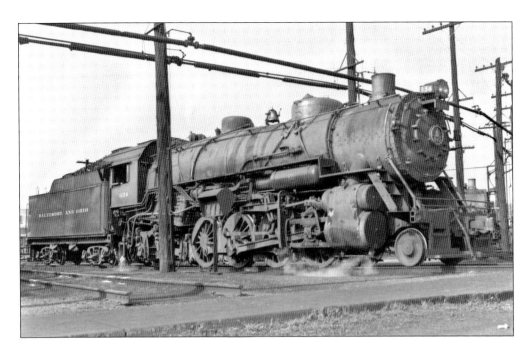

Pictured on these two pages are the author's all-time favorite B&O steam locomotives—its 100 Class Q-3 MacArthur engines. Baldwin Locomotive Works built them in 1918–1919 as the first representatives of the U.S. Railroad Administration's effort to standardize locomotive designs among all railroads. The engines received the 4500–4599 number series, which was changed to 300–396 in 1956 (three of them had been destroyed) to make room for four-digit diesel numbers. Above, Engine 356 (former 4558) rests at Parkersburg on Thursday, May 30, 1957, and below, Engine 334 (former 4535) serves as a backdrop for an employee photograph at Burnsville Junction that same year. (Above, Howard W. Ameling; below, *Richwood News Leader*/Bob Withers collection.)

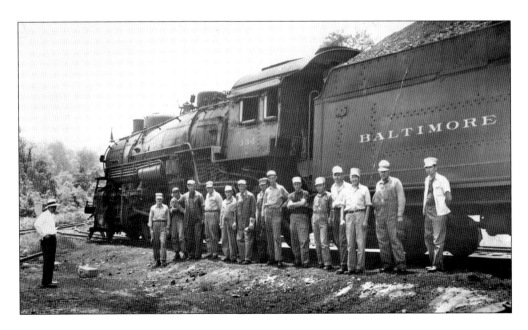

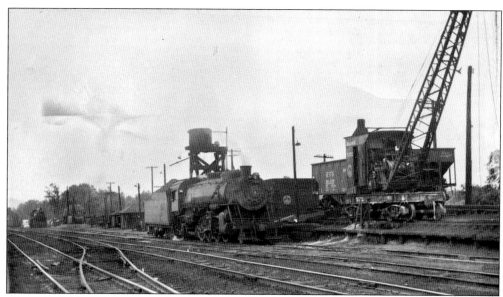

Above, Q-3 No. 4547 rests at the tiny engine terminal at Kenova on Thursday, September 27, 1956. She will return to Parkersburg that night on Train 92. All trains originated and terminated at the Kenova station, about a mile down the track. Hostlers ran the locomotives between the station and the shop. They filled their tanks with water and loaded coal into the tender's bunker with the clamshell on the elevated track. Below, engineer Bevan O. Wilcox waves from the cab of Light Engine 318 (formerly 4518) as he leaves the Huntington station to pick up his train on Tuesday, October 22, 1957, the last day steam operated into Huntington. The original Q-3, numbered 4500 (later 300), still reposes today in the Baltimore and Ohio Railroad Museum in Baltimore. (Above, W. J. B. Gwinn; below, *Herald-Dispatch*/Bob Withers collection.)

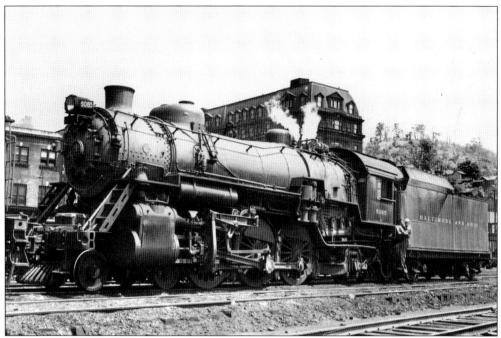

A Class P-1d Pacific-type passenger locomotive awaits assignment in front of the Grafton station and hotel on Wednesday, August 13, 1947. It is likely she will relieve a stronger locomotive on the westbound *Metropolitan Special* or some other daytime train following its crossing of the Allegheny Mountains. (Howard Ameling/Bob Withers collection.)

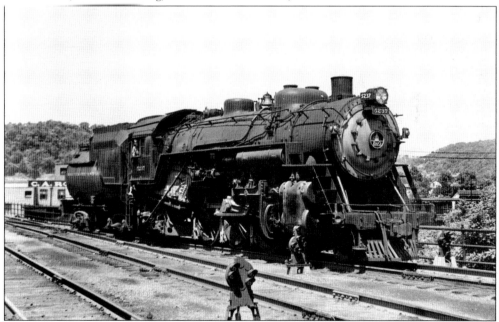

Class P-6a Pacific-type Passenger Locomotive 5237 backs out of the Wheeling station toward the Benwood shop after delivering Grafton-Wheeling Train 430 on Thursday, June 28, 1956. Baldwin Locomotive Works built her in 1922; she will remain in active service for a little more than a year. (Charles W. Aurand/Bob Withers collection.)

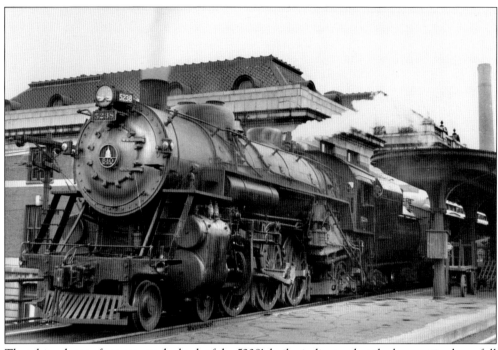

The white plume of vapor near the back of the 5238's boiler indicates that the locomotive has a full head of steam as she prepares to leave Wheeling with Train 233 in the summer of 1955. Her 74-inch driving wheels will soon be spinning furiously. (Charles W. Aurand/Bob Withers collection.)

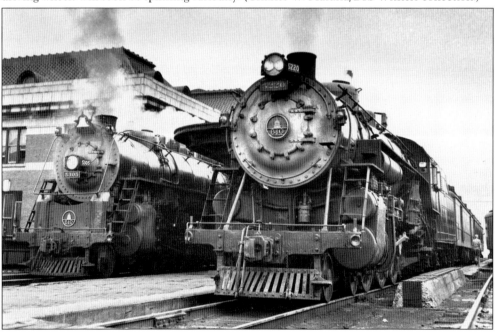

This view in Wheeling offers a comparison between two classes of B&O Pacifics. Class P-5 No. 5220, right, built by the American Locomotive Company in 1919, stands ready to depart for Kenova as soon as Train 233 leaves. Heading the latter run is Class P-7 No. 5305, a heavier engine built by Baldwin Locomotive Works in 1927. (TLC Publishing, Inc./Bob Withers collection.)

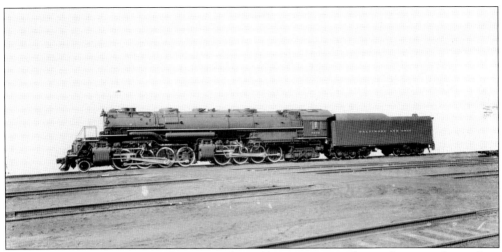

The massive size of B&O's mighty EM-1 class of locomotives might not be noticed save for a broadside builder's photograph such as this. The Baldwin Locomotive Works outshopped the 7602 in 1944, but with the rapidly advancing onslaught of diesels, she worked only 15 years. (F. Douglas Bess/Bob Withers collection.)

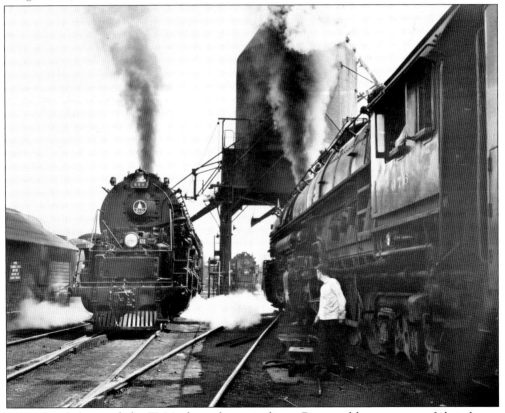

After diesels bumped the EM-1s from the main lines, Benwood became one of their home terminals. Here Engines 650, 676, and another unidentified sister in between them are serviced for their next runs in August 1957. Even with all their power and their young ages, they're living on borrowed time. (J. J. Young Jr./Bob Withers collection.)

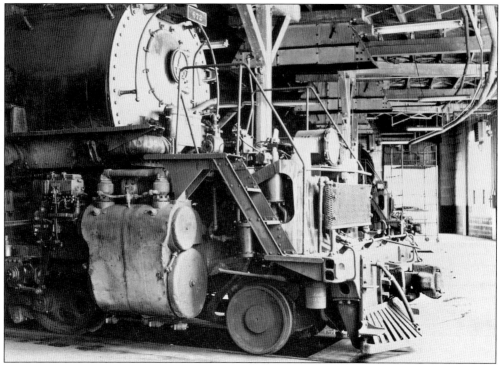

Large locomotives need large roundhouses, and the one at Benwood qualified. Above, Engines 672 and 677 simmer between assignments in 1957, while below, the photographer takes a closer look at the 677. Even at rest, the angular lines of these relatively modern beasts exude brute power. They were big-barreled and long—more than 125 feet, to be exact. Yet with all their axles equipped with roller bearings and with their cylinder cocks open, three workers could push one on level track. One wonders if the people who built this facility ever imagined it would stable such behemoths. (Both photographs Charles W. Aurand/Bob Withers collection.)

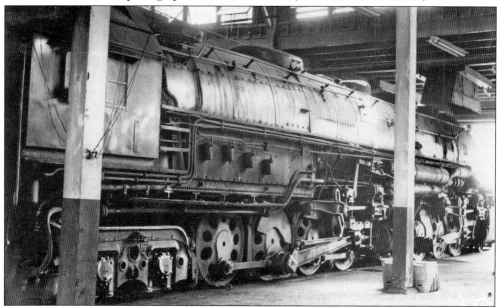

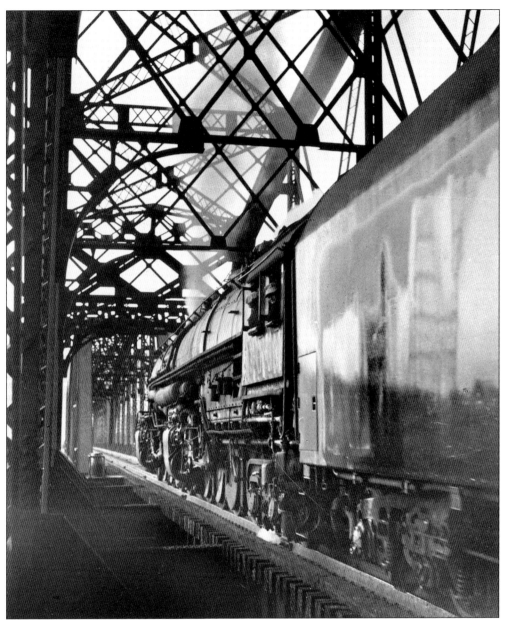

EM-1 Locomotive 7607 (renumbered 657 in 1957) hefts another trainload of coal across the Benwood bridge toward the lake ports of Ohio in September 1955. The big brutes were articulated—meaning they were equipped with two drive mechanisms under a single boiler. The first engine was hinged so it could negotiate curves independently of the second engine. Sometimes, on sharp curvature, this made for quite a bit of boiler overhang—readily visible to those watching from out in front—until the second engine chugged through the curve too. Other vital statistics include a total weight of 1.01 million pounds and tenders having a capacity for 25 tons of coal and 22,000 gallons of water. The 7600s, as railroaders referred to them, were all retired from train service by 1958. Two of them, the 651 and 659 (formerly 7601 and 7609), received a brief reprieve from extinction, supplying stationary steam power for an unfinished industrial plant near Moundsville. (J. J. Young Jr./Bob Withers collection.)

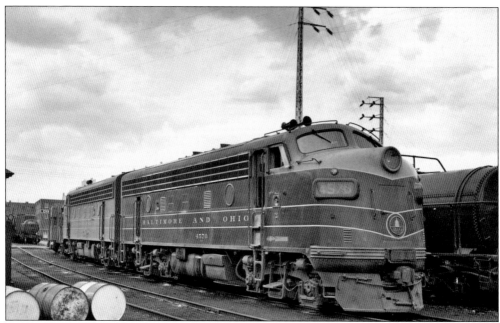

Diesels 4570 and 4499 are humming contentedly at the Huntington shop on Sunday, March 12, 1961. These are Class F-7 "wagontops," as crews called them, with 1,500 horsepower each, and they will take Train 92 to Parkersburg tonight. General Motors' Electro Motive Division built them as part of a set of 176 units that were outshopped between 1948 and 1953. (John P. Killoran/Bob Withers collection.)

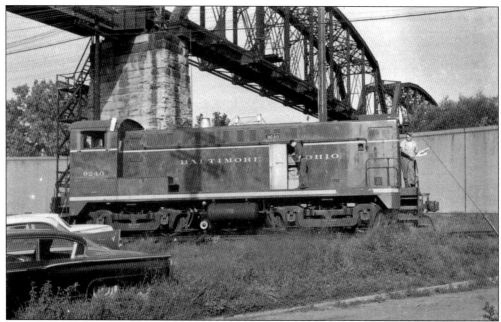

Baldwin Locomotive Works made its fortune building steam locomotives, but the company made diesels too. Here engineer Ira Starkey, on the front of Yard Engine 9240, and an unidentified fireman give the 1948 unit the once-over before going to work on Wednesday, August 28, 1963, in Parkersburg's Low Yard. (Bob Withers.)

Five

SPECIAL MOVEMENTS

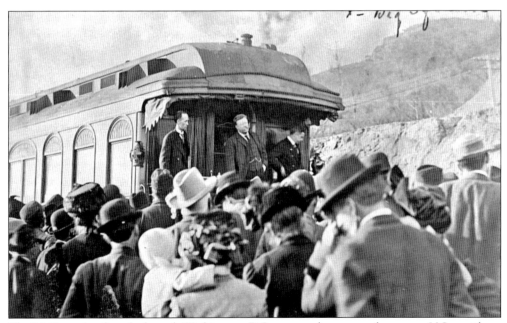

The B&O, passing directly through Washington, D.C., attracted patronage from many U.S. presidents and presidential candidates. Here Theodore Roosevelt campaigns on the Progressive Party "Bull Moose" ticket in Point Pleasant. It is Thursday, April 4, 1912, and TR, a former Republican, already has served as president from 1901 to 1909. (Gordon C. Jackson/Bob Withers collection.)

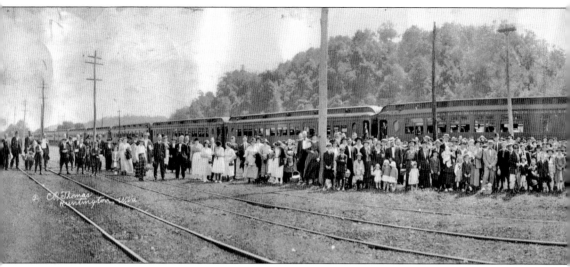

An excursion sponsored for employees, retirees, and the public by the Baltimore and Ohio Veterans Association in Parkersburg has just arrived for an annual outing at Camden Park, just west of Huntington, on Sunday, September 12, 1920. A surviving brochure from an identical trip in 1950 advertises stops in Ravenswood, Millwood, Mason City, and Point Pleasant for round-trip

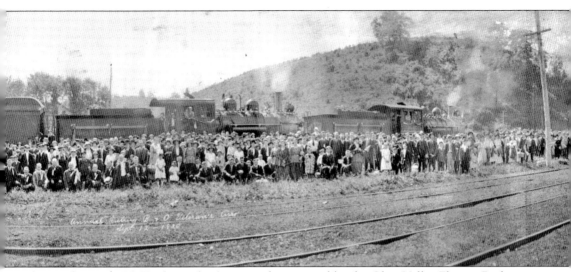

fares as low as $1.75. Tracks in the foreground are owned by the Ohio Valley Electric Railway Company; in fact, it was the streetcar line that built the 14-acre amusement park as a way to drum up patronage. (C. R. Thomas Studio/Paul Fulks collection.)

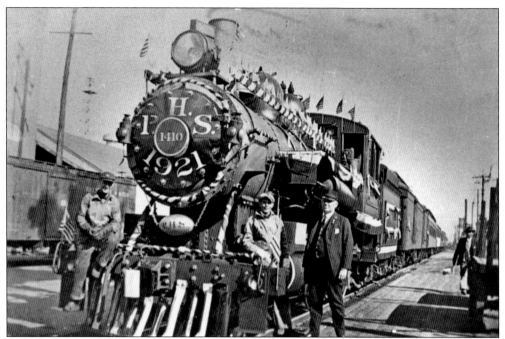

Posing in front of a gaily decorated excursion in 1921 are, from left to right, engineer John Matheny, fireman Roscoe Roush, and conductor Charles Riggs. The train has just brought hundreds of Parkersburg High School students and chaperones to Huntington for a football game against Huntington High School. This is the first such special sponsored by the Parkersburg Lions Club; the custom will continue another 40 years. (Charles S. Ruddell/Bob Withers collection.)

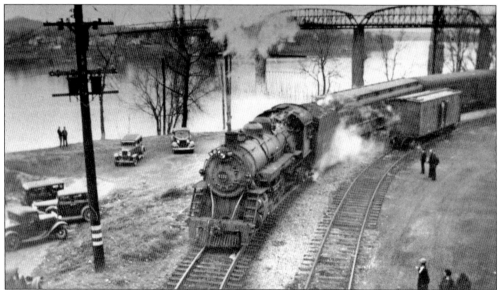

Here is another football special, this time from Weirton High School—via the Pennsylvania Railroad as far as Wheeling—in Parkersburg in 1934. The train has been unloaded on the elevated track at Ann Street Station (where the photographer is positioned) and is heading around the transfer track from the Low Yard to the High Yard for servicing. (Stephen P. Davidson/Bob Withers collection.)

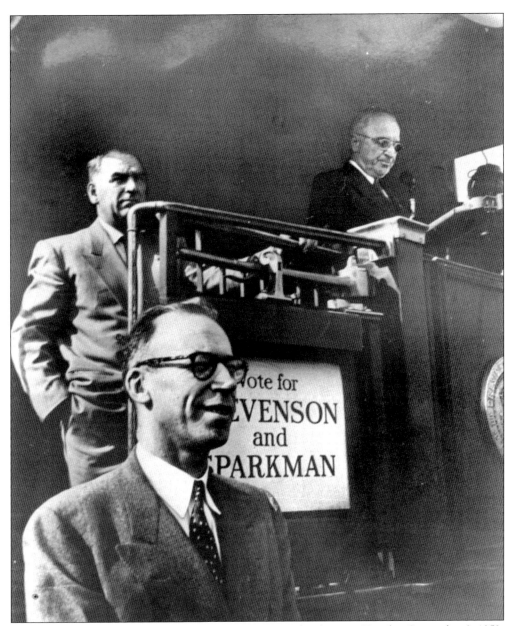

President Truman campaigns for Adlai Stevenson in Parkersburg on Tuesday, September 2, 1952. Beside Truman on the rear of the armor-plated presidential private car *Ferdinand Magellan* is Secret Service agent Harry Nicholson. On the ground is Truman speechwriter Ken Hechler, who later served as a U.S. congressman and West Virginia secretary of state. Just before arriving in town, Truman asked Hechler to fetch him a Bible. The president found the passage in Matthew, chapter six, where Jesus denounces hypocrites' prayers. Before a whistle-stop audience of 3,500, Truman compared the hypocrites to John Foster Dulles, Republican contender Dwight Eisenhower's foreign policy adviser, who posed as a defender of the captive people in communist Eastern Europe. Truman then sent reporters to their dictionaries when he contended that the Republican "snollygosters" should read and be governed by the New Testament. He finally told them the word refers to "a pretentious, swaggering, prattling fellow." (Ken Hechler/Bob Withers collection.)

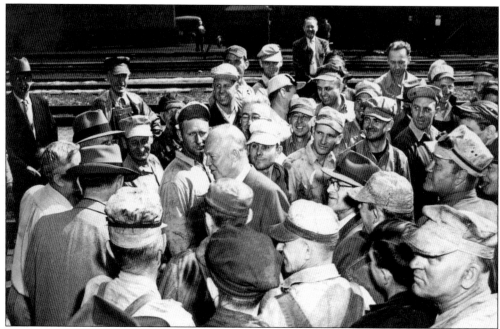

Now it is Ike's turn. The images on this page were taken during the World War II hero's campaign stop in Huntington just before noon on Wednesday, September 24, 1952. Above, he disembarks from his private car to hobnob with several railroaders who obviously are delighted at being granted the impromptu meet and greet. While the candidate snags a few more votes outside, his wife, Mamie Doud Eisenhower, poses in the dining room of the private car with several local Republican women. The group includes, from left to right, Martha Ensign, Madeline Morris Regel, Shirley Stanard Swihart, Mamie Eisenhower, Betty Reckard King, and Nancy Robinson Fitzwater. (Both photographs Weirton Steel/Eisenhower Library collection.)

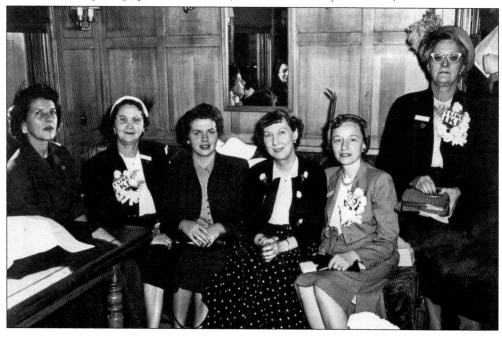

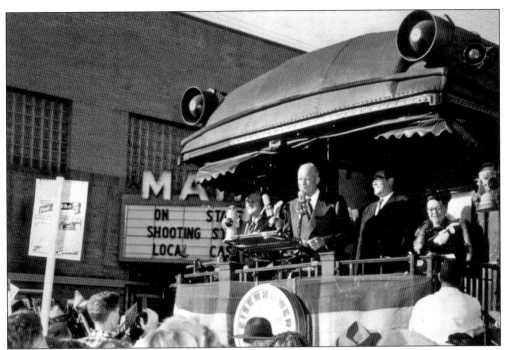

Later in the day, Eisenhower, above, makes a campaign speech while his train is stopped in the middle of St. Marys' Second Street. Ike is heading for a historic meeting in Wheeling with his running mate, Richard Nixon, ostensibly to let him know whether he is still on the Republican ticket after revelations about Nixon's "secret fund." Unbeknownst to most, the deal already was struck when, earlier in the day, Ike and Sherman Adams, his chief of staff, left the train in Portsmouth, Ohio, huddled in a telephone booth, and talked to GOP officers in Cleveland. Below, Eisenhower, looking a bit bewildered and clutching a key to the city, makes his way through a crowd in the Wheeling station to a waiting limousine. (Above, Weirton Steel/Eisenhower Library; below, J. J. Young Jr./Bob Withers collection.)

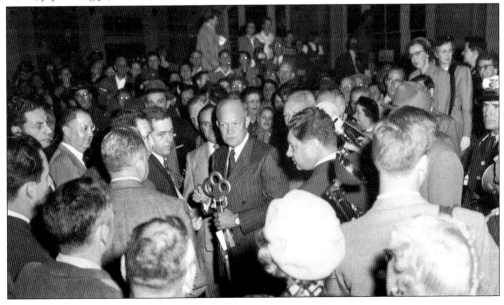

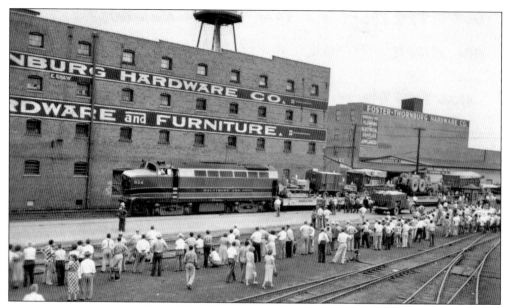

This special movement has drawn a crowd. It is a Ringling Brothers and Barnum and Bailey Circus train arriving in Huntington some time in 1951. Perhaps of lesser interest to the general public, the train also represents the arrival of the first B&O diesel-electric locomotive in Huntington. (Charles Lamley/Bob Withers collection.)

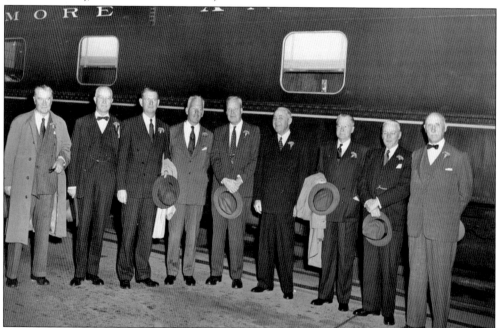

B&O officers and directors arrive in Huntington on Thursday, October 18, 1951, during their annual railroad inspection trip. From left to right, they include Stewart McDonald of Baltimore, John Traphagen and Lawrence Marshall of New York, J. Hamilton Cheston of Philadelphia, Richard Harte of Parkersburg, B&O president Roy B. White of Baltimore, John Biggers of Toledo, James Cunningham of Chicago, and Robert Garrett of Baltimore. (The *Herald-Dispatch*/Bob Withers collection.)

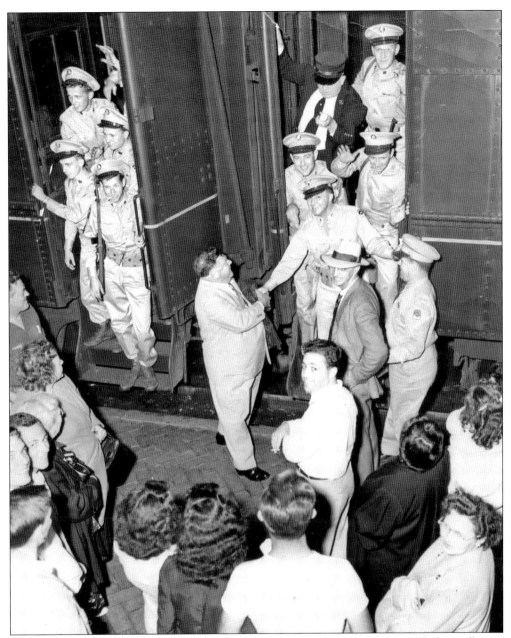

With a member of Train 78's crew looking a bit impatient, Mayor Walter Payne bids goodbye to the U.S. Army Reserve's 914th Postal Unit on Labor Day, September 4, 1950, before the men leave Huntington for Fort Meade, Maryland, to replace a unit that has been ordered to Korea. The 17 troops will squeeze into sections 6 through 11 of the regular 12-section drawing-room sleeper military style—that's two men to a lower berth, except the commander, of course, and one to an upper—for the overnight journey to Pittsburgh. The next morning, the men will race across the Monongahela River bridge in the Steel City and catch a connecting train to Washington, D.C. The active duty call-up will nearly paralyze the Huntington post office and delay its deliveries—because that's where they all work—until replacements can be trained. (Lawrence V. Cartmill/Bob Withers collection.)

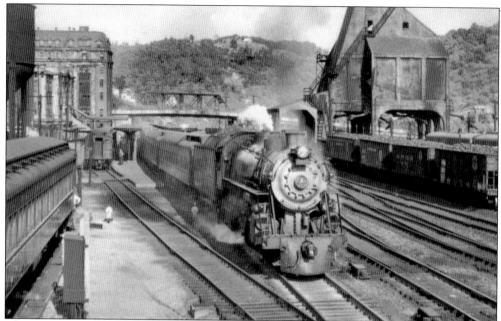

The classic station and hotel are in the background at Grafton as a westbound troop train referred to only as MAIN 2805—Military Authorization Identification Number—departs with another load of troops headed for Korea. Thankfully a truce will be worked out in the three-year-old Korean War in about two months. (Philip R. Hastings/*Classic Trains* collection.)

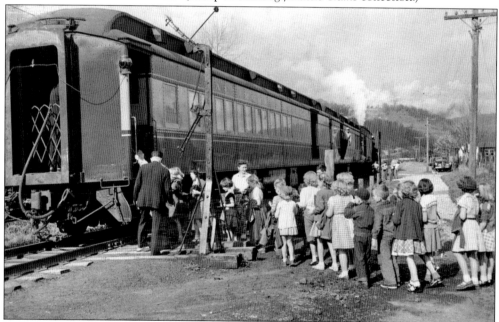

Lota Frazier's third-grade class boards Train 136 at Richwood in April 1954 for a ride down to their teacher's home a mile and a half away for a near-the-end-of-the-school-year picnic. It looks like at least half of the combination passenger/baggage coach's 48 seats will be filled, at least for a few minutes on this small segment of the train's journey through the West Virginia hills. (*Richwood News Leader*/Bob Withers collection.)

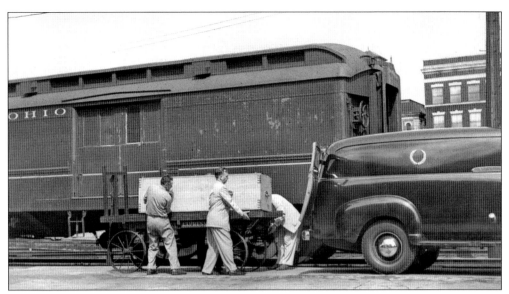

The grim reaper has struck again. The body of a deceased person has come home for burial as personnel from the Altmeyer Funeral Home unload a coffin from Train 246's express car after its arrival in Wheeling in the 1950s. In those days, the Railway Express Agency carried many folks to their final resting places. (J. J. Young Jr./Bob Withers collection.)

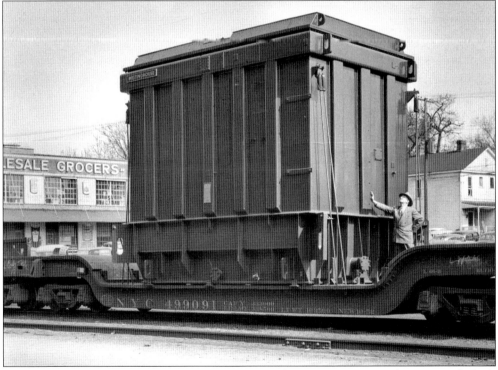

Chief clerk Ralph W. Brafford sizes up a 299,500-pound transformer mounted on a specially built depressed-center flatcar in Huntington on Wednesday, April 22, 1953. Later in the day, B&O will forward the special shipment to the Appalachian Power Company plant 65 miles up the Ohio River at Graham. (Charles Lemley/Bob Withers collection.)

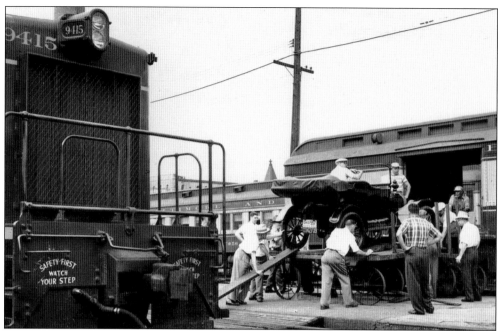

Shriners load a vintage 1916 automobile onto an express car in the Wheeling terminal in August 1958. Later in the day, the express car will be part of an excursion taking the local Shriners to their annual convention in Kansas City. Shriners' specials operated out of Wheeling for years. (J. J. Young Jr./Bob Withers collection.)

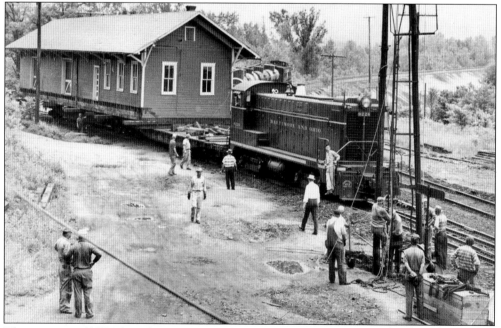

The expansive 1907 union depot at Point Pleasant has outlived its usefulness in 1960, and the B&O has purchased the old New York Central freight house to be its "new" station. Here, on Thursday, May 26, engineer Harry Nixon carefully eases the replacement structure—mounted on two flatcars—toward its new location facing the B&O main line. (Bob Withers collection.)

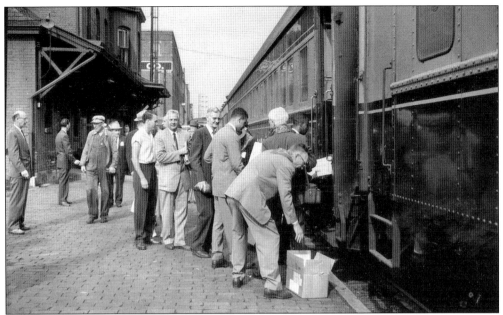

More than 350 business leaders, shippers, and other prominent citizens prepare for an unusual ride on Tuesday, May 12, 1959, sponsored by Huntington's Railroad Community Committee and the Huntington and Ceredo-Kenova chambers of commerce to show them business opportunities along local rights-of-way. Above, they board B&O coaches in front of the passenger station; below, they find excellent observation posts in Norfolk and Western (N&W) freight gondolas. The tour will cover B&O territory, switch to the N&W in Kenova, and then take the C&O to Barboursville and back to Huntington. Douglas C. Turnbull Jr., a B&O vice president, will address the travelers later during a luncheon at the Hotel Prichard. (Charles Lemley/Bob Withers collection.)

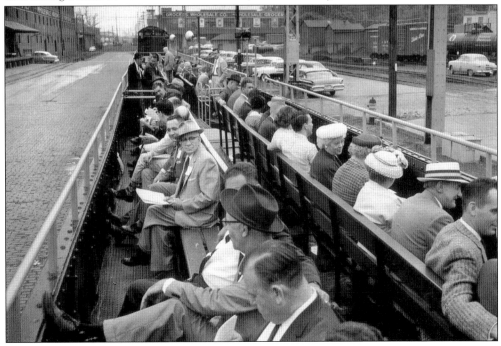

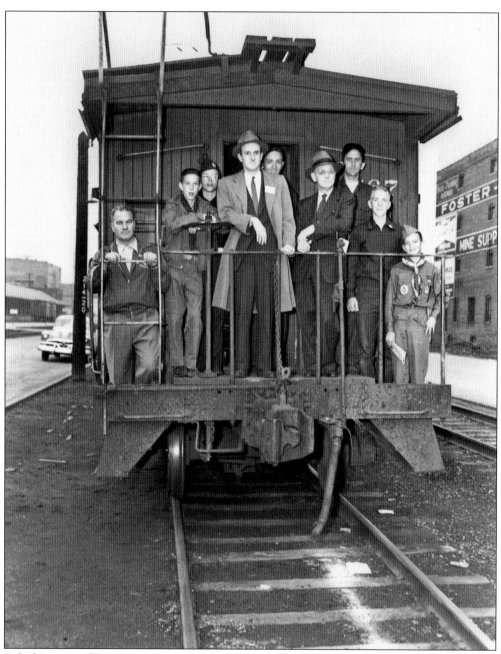

A lucky group of Boy Scouts—who, no doubt, are working on their railroad merit badges—are about to enjoy a caboose trip from Huntington to Kenova on Saturday, April 23, 1955. The man in the dark suit is chief clerk Ralph W. Brafford, who is acting as trip escort. The 8-mile trip became a favorite of local railroad enthusiasts after B&O combined the yard limits in the two cities and began shuttling all the freight between them with yard engines instead of through freight trains. Riders often saw small children run out to the right-of-way and shout "Chalk! Chalk!" as the trains approached; this stemmed from the congenial crews' custom of throwing off dozens of fat pieces of chalk the company supplied to yard clerks to mark track assignments on the sides of incoming freight cars. (Charles Lemley/Bob Withers collection.)

Six

WRECKS

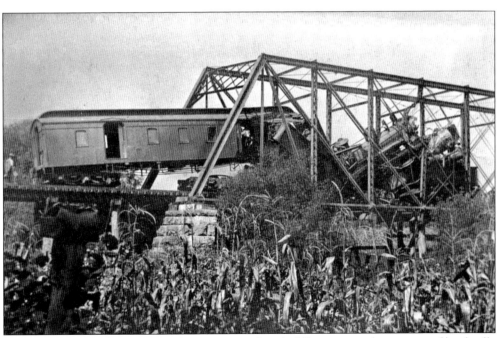

Despite the best safety practices, sometimes railroads fell victim to disastrous and/or deadly derailments. B&O was no exception. Here the fellows in the mail car are peering out the door as if they are saying, "Wha' happened?" The photograph dates from the 1890s and shows an accident on the Guyandotte River bridge between Guyandotte and Huntington. (Fred Lambert/ Bob Withers collection.)

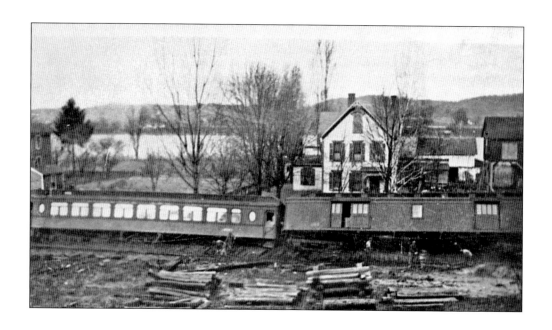

A broken rail derailed the second engine and six of Train 78's nine cars in front of the Glenwood station at 11:50 p.m. on Thursday, December 11, 1919. Among the nine passengers and one express messenger injured was a man who suffered a broken leg and missing teeth; another received a dislocated shoulder. H. H. Morris, a former C&O superintendent, was climbing into his berth at the time of the accident but escaped with only a wrenched ankle. Sixteen taxis were dispatched to take passengers who didn't want to resume their journey back to Huntington; a relief train dispatched from Parkersburg picked up the remainder. Five of the cars partially overturned against an embankment; the train was just 50 yards beyond a deep fill when it upset. (Both photographs *Huntington Advertiser*/Bob Withers collection.)

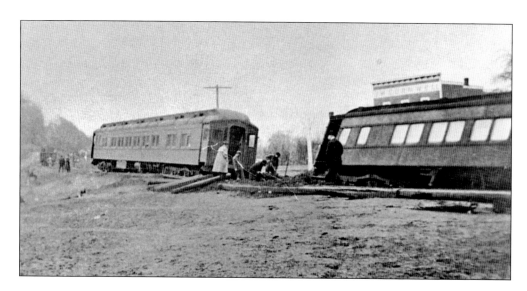

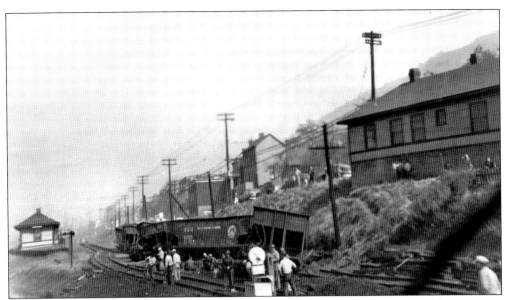

Coal cars lie in a twisted heap on the approach to the Ohio River bridge at Benwood Junction on Friday, October 8, 1948. The photographer is aboard Train 73, which had just departed the station at left. "The conductor on train 43 did not tell me about it; consequently I saw it too late," he wrote. "Coming back down the river on 73, I was prepared." (O. V. Nelson/Bob Withers collection.)

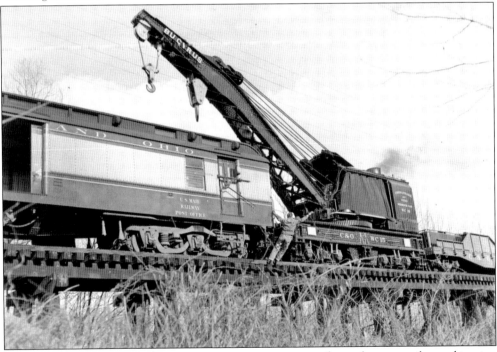

A C&O wreck train crew works in a precarious position—on a pile trestle—to rerail a combination mail/express/baggage car after Train 82 derailed on Saturday, December 26, 1953, less than three miles from its point of origin in Kenova. B&O found it easier to call C&O for help with accidents in the Huntington area rather than wait on a wreck train from Parkersburg. (Charles Lemley/Bob Withers collection.)

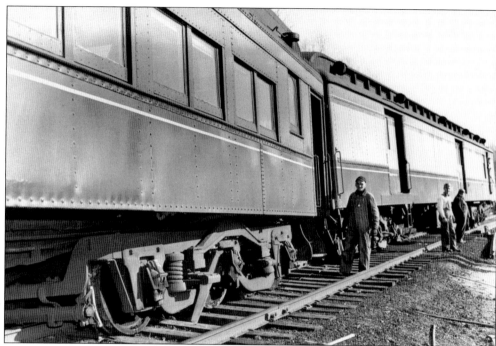

Railroaders assess the damage after the aforementioned derailment of Train 82, in which its combination mail/express/baggage car and coach left the rails east of Kenova on Saturday, December 26, 1953. One wonders, if there were any passengers on board that morning who may have been trying to get home after Christmas, how they were evacuated to find alternate transportation, since the right-of-way is in the woods a good distance from U.S. 60, and perched on a high embankment at that. It is fortunate, however, that the cars have come to rest just short of a tall trestle. (Both photographs Charles Lemley/Bob Withers collection.)

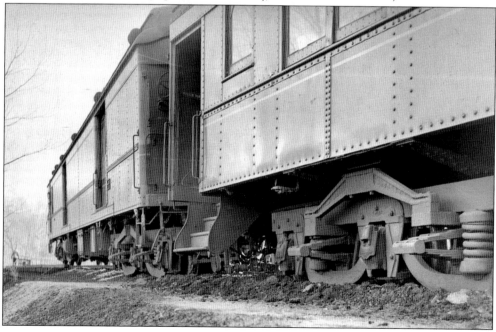

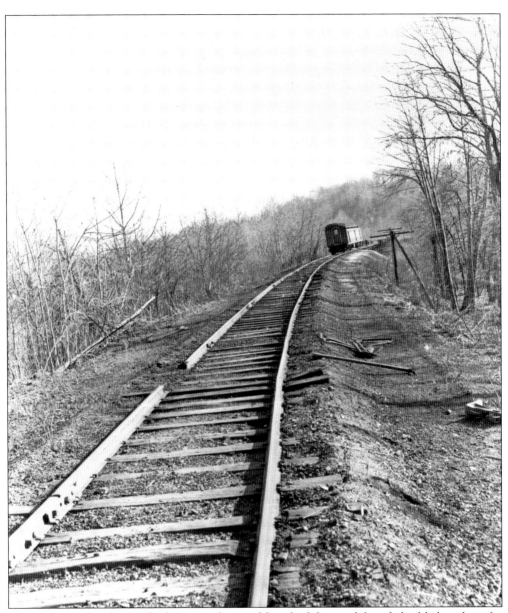

The photographer has walked westward several hundred feet and found the likely culprit for the December 26, 1953, wreck—a broken rail. Doubtless the pictures were made to provide evidence for the investigation sure to follow. Within a few months, service on Trains 81 and 82 will be downgraded anyway. Instead of offering passenger accommodations, Railway Express shipments, and mail-sorting capabilities en route in both directions between Parkersburg and Kenova daily except Sunday, the company will drop one side of the trains and substitute a single combination passenger/baggage coach for the two cars on July 5, 1954. Thereafter the locals will offer only passenger, baggage, and express service, but no mail carriage, and the trains will operate westbound on Mondays, Wednesdays, and Fridays and eastbound on Tuesdays, Thursdays, and Saturdays. Passengers will still be more or less welcomed according to that pattern, first in a coach and then in a caboose, until the Amtrak takeover on May 1, 1971. (Charles Lemley/Bob Withers collection.)

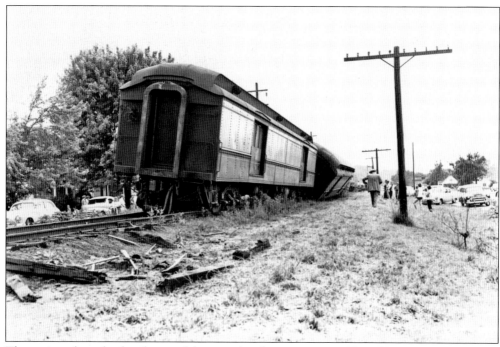

These views show the derailment of three mail and express cars on Train 72 in West Huntington at 1:15 p.m. on Tuesday, May 25, 1954. Neither the locomotive nor the rear car, a coach, left the rails. There were few if any passengers on board at the time, but a group of 30 schoolchildren planning to ride from Huntington to Point Pleasant and return was forced to forego the outing. Since the rickety right-of-way was paralleled by roadways—Waverly Road/U.S. 60 on the north and Wayne Street on the south—the mishap quickly attracted dozens of sightseers. (Both photographs Charles Lemley/Bob Withers collection.)

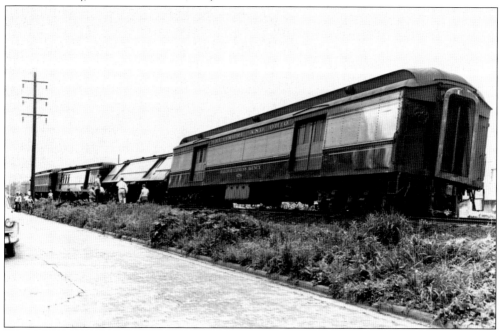

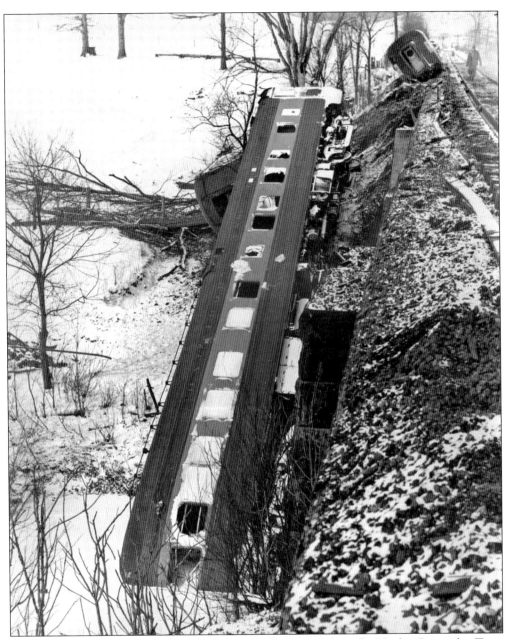

B&O sleeper/lounge/observation car *Wabash River* lies on its side in the Hughes River after Train 31, the westbound *National Limited*, derailed on a curve just west of Toll Gate on the morning of Friday, February 24, 1967. Four people have been killed—two passengers, a Pullman Company porter, and B&O flagman Wade J. Greathouse. Perhaps Greathouse's death is the most ironic—the train had detoured around an earlier derailment and was running so late that its regular flagman was out of time. Greathouse was pulled off his regular job in the freight pool to fill in. He wasn't even wearing a passenger crewman's uniform. As a matter of fact, the author ran into him the previous summer as he boarded the same train in Parkersburg with his family for a vacation trip. He said that would be his first ride on a train when he wasn't working. (Larry K. Fellure Sr./Bob Withers collection.)

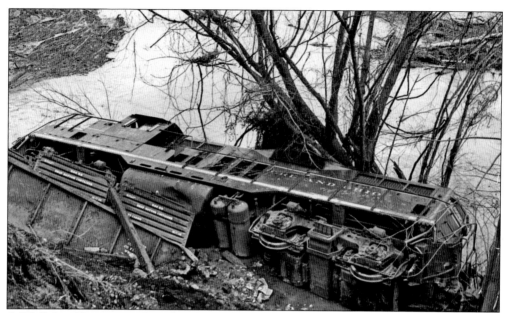

A B&O diesel lies on its side at the edge of the Ohio River after it and nine freight cars on Train 92 derailed following a washout near Letart on Wednesday night, February 10, 1960. Engineer H. D. Bee said his first thought after the plunge was that he might drown, but that gloomy possibility was thwarted by a clump of providentially positioned sugar maple trees. (John P. Killoran/H. D. Bee collection.)

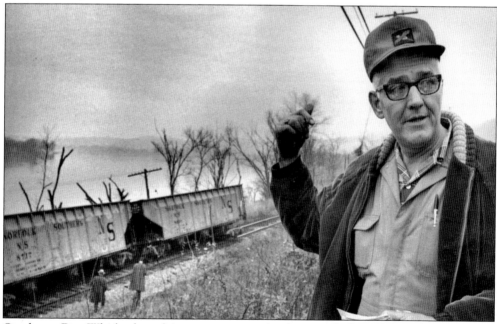

Conductor Don Whitlatch explains to a reporter what happened when 17 cars of 102-car Train 103 derailed beside the Ohio River at 11:55 a.m. on Wednesday, December 18, 1968, two miles east of Guyandotte. Whitlatch was thrown to the floor of his caboose by the sudden stop, which jackknifed four of the cars near the rear end. Neither he nor anyone else was injured. (*Huntington Advertiser*/Bob Withers collection.)

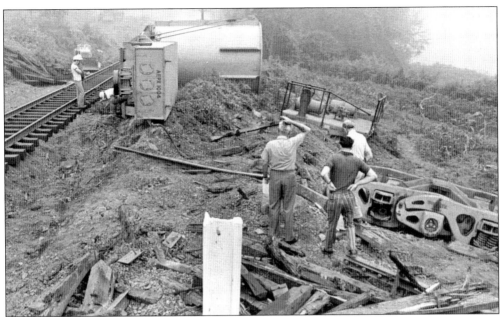

A top-heavy American Electric Power transformer lies on its side three miles east of Guyandotte in July 1974 after literally falling out of Freight Train 104. The fellow in the photograph above is scratching his head, possibly because he's trying to figure out how to get the overturned device back on the rails. The colleague in the photograph below seems to be giving up the problem in frustration. Probably some of that frustration resulted from the fact that the power company advised B&O to run the car by itself in a special train rather than risk just such an occurrence, but the railroad played Scrooge and didn't listen—until the lesson was learned and the rerailed car departed the second time, in a special train. What's the old saying? Something about being penny-wise and pound-foolish, perhaps. (Both photographs *Herald-Dispatch*/Bob Withers collection.)

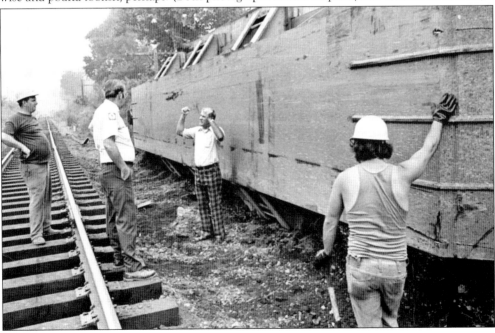

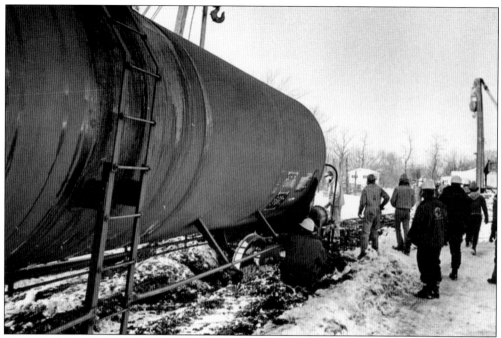

Crews work hard to keep from freezing while they clean up a derailment at Baden, just east of Point Pleasant, on Monday, January 23, 1978. Freight Train 103 spilled eight cars as it rolled through town at 4:25 a.m. One of the derailed cars spilled more than 20,000 gallons of toxic epichlorohydrin near the city's water supply, prompting a precautionary evacuation of 300 nearby residents. (Lloyd D. Lewis/Bob Withers collection.)

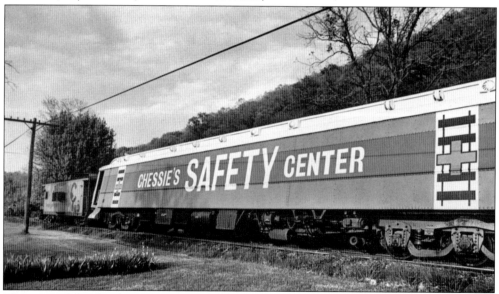

The irony of the derailment of nine cars and a caboose of a westbound freight train at Lesage on Wednesday afternoon, May 2, 1979, is that one of the victims is "Chessie's Safety Center," a converted passenger coach that roams the system so instructors can teach railroaders how to keep just this type of event from happening. The embarrassing incident injured conductor W. H. Trussell. (*Herald-Dispatch*/Bob Withers collection.)

Seven

STRUCTURES

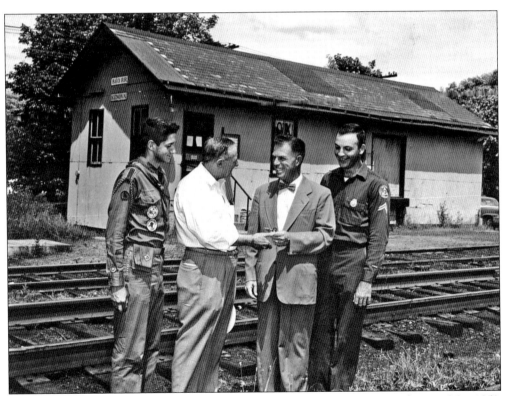

Even stations that are no longer needed can serve useful purposes, as seen here in May 1959. Clyde Farmer Jr., B&O's smiling district freight agent, hands the keys to the Kenova depot to John Kemple, president of the Ceredo-Kenova Chamber of Commerce, for use as a new headquarters. Jimmy Cook, left, of Scout Troop 84, and Larry Hatten, a Civil Defense auxiliary policeman, look on. (*Huntington Advertiser*/Bob Withers collection.)

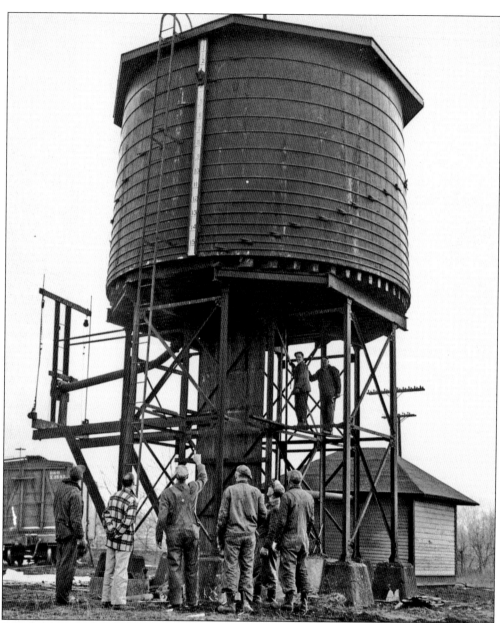

It is Monday, January 20, 1958, and since B&O's Parkersburg-Kenova line has been dieselized now for three months, westbound train crews terminate their runs in Huntington. After all, the only reason they went to Kenova was to service and turn their steam locomotives. Here crews make plans to dismantle the old 55,000-gallon water tank at Kenova because it has been donated to Camp Arrowhead, the local Boy Scout camp near Ona, for use as a reservoir. The tank, constructed primarily of wood staves, will have to be completely disassembled for the move and reassembled in the spring. The camp already is supplied with a pressure system that provides water for drinking and cooking; the tank will be placed on top of a hill and will feed water by gravity into the camp's sanitary system and showers. District Scout executive and camp director Edward J. Hall, in the checkered jacket, and Ervan L. E. Evans, B&O's carpenter foreman pointing upward, are among the men in the photograph. (*Huntington Advertiser*/Bob Withers collection.)

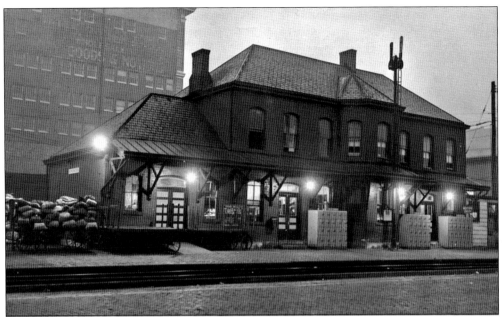

A couple of people can be seen milling around inside the Huntington passenger station in this 1953 photograph, even though it is just after 6:00 a.m. and barely daylight. Westbound Passenger Train 77 from Pittsburgh has arrived and departed—note the sacks of mail on the baggage cart—and eastbound Local 82 has picked up its freight cars and proceeded toward Parkersburg. (Charles Lemley/Bob Withers collection.)

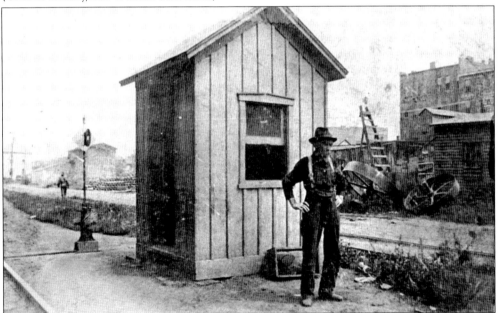

Railroad structures do not have to be large to be functional. Here crossing watchman William Christopher Stevens enjoys an idle moment outside his shanty at the corner of Second Avenue and Tenth Street, a block west of the Huntington station, in 1908. When trains were coming, Stevens had to be especially vigilant—the main line went right down the middle of Second Avenue. (*Herald-Dispatch*/Bob Withers collection.)

Guyandotte became a part of Huntington in 1911, but for years it was an independent town. In fact, it served as B&O predecessor Ohio River Railroad's western terminus from 1888 to 1892. The combination depot, with the agent/operator's traditional bay window in between the waiting room and freight warehouse, was torn down in 1934. (Helen Diddle/Bob Withers collection.)

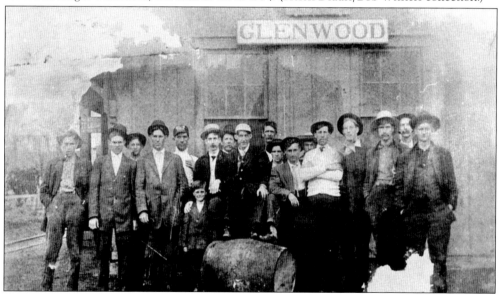

If ever there was a photograph proving that the depot was a small town's gathering place, this is it. A group of young men pose for the camera at Glenwood in the early years of the 20th century. One wonders how many of them have bought a ticket to ride. (Minnie Finley/Gladys Paden collection.)

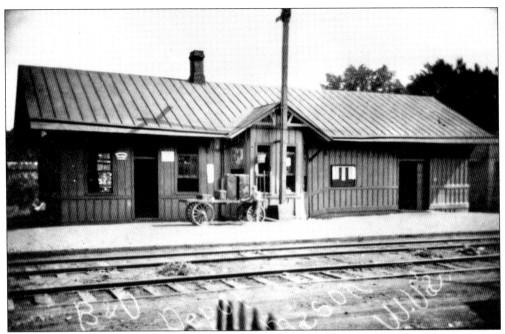

The Mason City depot was roughly halfway between Parkersburg and Kenova. Sharp eyes may see a little boy loafing next to the baggage cart and another seated at left in the shade of the waiting room. At one time, four pairs of passenger trains called here daily. (C. R. Davidson/Bob Withers collection.)

This photograph, taken in 1949, shows that the Mason City station has lost its waiting room in the intervening years. The building is where operator Cliff Bellamy studied telegraphy under Jimmie Diehl. The station is gone today, but passersby can see the old brick platform, including the cutout where the building's bay window once stood. (Cliff Bellamy/Bob Withers collection.)

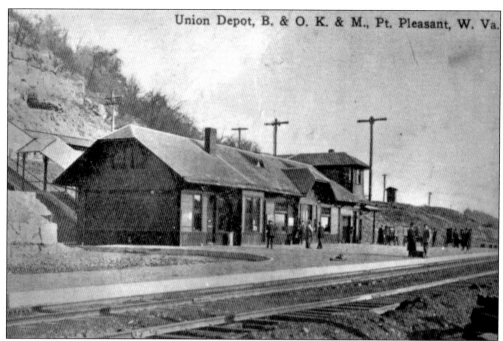

The Point Pleasant rail yard was turned inside out in 1909 when the New York Central (NYC) relocated its tracks from under the B&O line to the hillside above it. At NYC's expense, the B&O passenger station, which dated from the 1890s, was expanded and became a union depot. NYC passengers reached the waiting room via the concrete steps at left. (Mid-America Paper Collectibles/Bob Withers collection.)

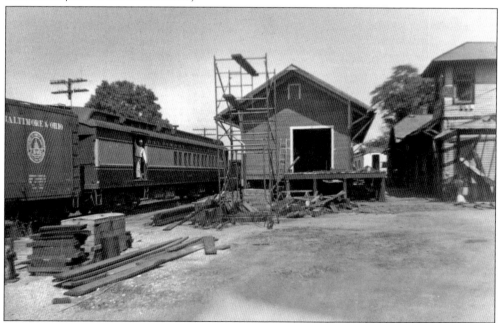

Local 82 departs Point Pleasant on Thursday, July 7, 1960. The old union depot at right is ready to be torn down, and its replacement, recently having been purchased from NYC and moved by rail into place (see photograph on page 78), is being renovated. (Bob Withers collection.)

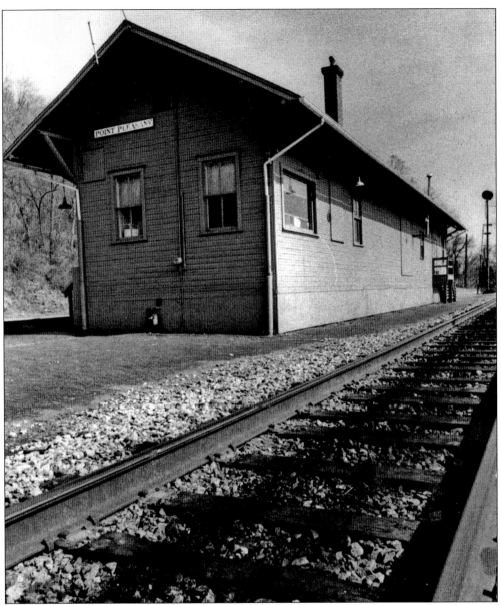

This photograph shows the Point Pleasant depot as it looked in March 1987; it is similar in appearance today, except that some windows have been blanked. The building, which replaced an earlier structure in 1960, welcomed a few B&O passengers—mostly hardy railroad enthusiasts wanting to ride the overnight freight trains' cabooses—until the advent of Amtrak in 1971. It also briefly served NYC passengers riding a self-propelled Rail Diesel Car across the Ohio River in the days immediately after the adjacent two-lane Silver Bridge collapsed on December 15, 1967, with a horrendous loss of life. The NYC shuttle lasted until a ferry boat could be placed in operation; the four-lane Silver Memorial Bridge that was built nearby to replace the fallen span was completed in just two years. The operator's office in the station was closed on January 31, 1988. Now the building is used as an office by the Point Pleasant district run's crew and serves as a base of operations for track maintenance forces in the area. (*Herald-Dispatch*/Bob Withers collection.)

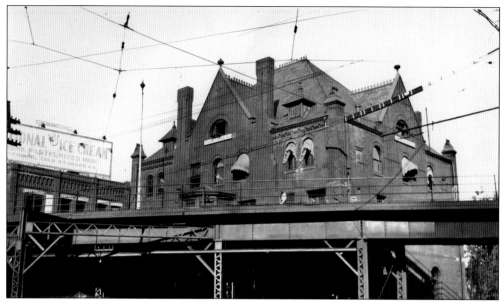

For most of its existence, two B&O stations served Parkersburg. Ann Street, above, was built in 1887 for passengers using the Wheeling-Kenova line. The track reached its waiting rooms on an elevated approach to the Little Kanawha River bridge. The ticket office was closed on April 26, 1954; thereafter, passengers paid cash fares. The building finally was razed in 1959 and its bricks used to pave city streets. Sixth Street, below, was situated just east of the Ohio River bridge and served the Baltimore–St. Louis main line. Built in 1857 and expanded in 1871, it was torn down in November 1973 to make room for a bank's parking lot. A small block structure nearby served Amtrak's periodic service until that, too, finally ended in 1981. (Above, Interstate Commerce Commission; below, Baltimore and Ohio Railroad Museum, Inc., Hays T. Watkins Research Library/Bob Withers collection.)

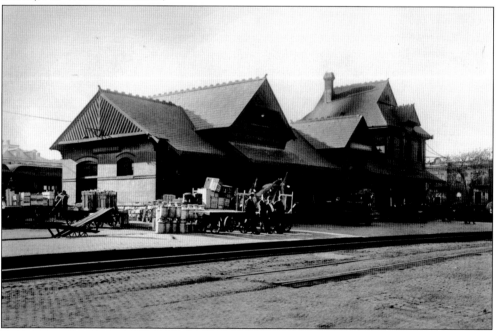

Towers were usually two-story buildings where telegraph operators received orders from dispatchers to deliver to train crews telling them where to meet trains, wait at certain points, proceed slowly on bad track, and so forth. In Parkersburg, MS Tower, at right, was the first such building in the Low Yard, and it was located near the Ohio River Railroad roundhouse and shops. It was eventually replaced by SX Tower, below, built nearer to Ann Street Station at the west end of the yard. The High Yard boasted several towers over the years, including OB, YD, and SY—the letters were their telegraph call signals. Later communications from dispatchers and other officers were received by telephone. The towers are all gone now, and communications are handled directly between dispatchers and crews by radio and fax. (Right, ICC/Bob Withers collection; below, John King collection.)

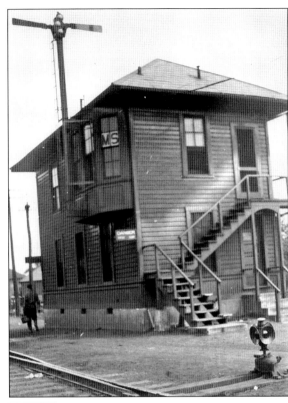

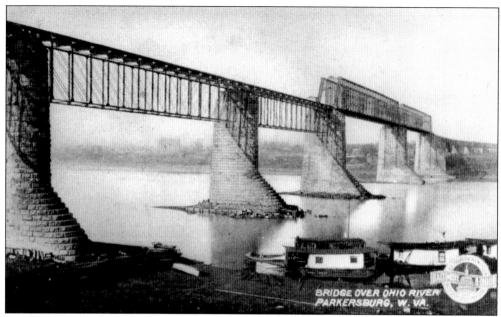

The original Ohio River bridge at Parkersburg was built in 1871. Before that, passengers reaching Parkersburg from the east boarded river steamers to connect with the Marietta and Cincinnati Railroad. Even though much of the old Baltimore–St. Louis line is gone, the span, rebuilt in 1904–1906, still gives yard crews access to plants on the Ohio side of the river. (Baltimore and Ohio Railroad Historical Society/Bob Withers collection.)

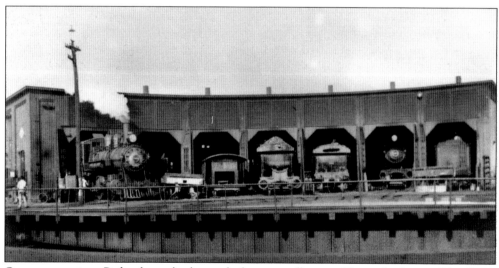

Once upon a time, Parkersburg also boasted of two roundhouses. This is the former Ohio River Railroad facility in the Low Yard c. 1920. It was destroyed fairly early, and locomotives for trains in both the High Yard and Low Yard were dispatched from the surviving facility near Depot Street in the High Yard. (John King collection.)

Railroad restaurants often were referred to as "greasy spoons" for obvious reasons. At least the M&M Restaurant, across Green Street from Parkersburg's Sixth Street Station, was open 24 hours a day, and a weary passenger, railroader, or enthusiast could eat his or her fill of cheeseburgers at any hour. As passenger service declined and dining cars were removed, conductors began taking orders from their passengers well in advance of Parkersburg and dropping off notes at the next open office to have the M&M deliver lunches to their famished clientele on arrival in town. In one case in 1941, a harried chef on a troop train ordered 40 pounds of butter, six cases of pork and beans, four cases of tomatoes, 40 quarts of ice cream, 100 pounds of beef roast, 80 pounds of pork chops, and four issues each of *Time* and *Newsweek*. Most of it was delivered, on time, by the M&M. (Nancy Taylor/Bob Withers collection.)

This combination station is at St. Marys, located at the spot where the B&O's private right-of-way starts down Second Street. The photograph was made at noon on Sunday, April 24, 1955; into the 1960s, accommodating operators found ancient waybills and other forms long fallen and forgotten behind cabinets and turned them over to railroad enthusiasts. (W. J. B. Gwinn/Bob Withers collection.)

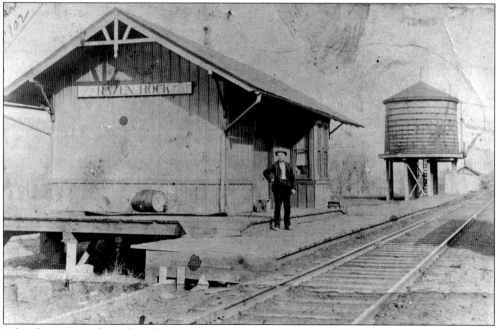

A lonely man—perhaps the ticket agent or an impatient passenger—awaits the next train at Raven Rock, population fewer than 100, in 1902. The helpful station sign not only informs passengers where they are, but also that they are 59.5 miles from Wheeling and 163.4 miles from Kenova. (Bob Withers collection.)

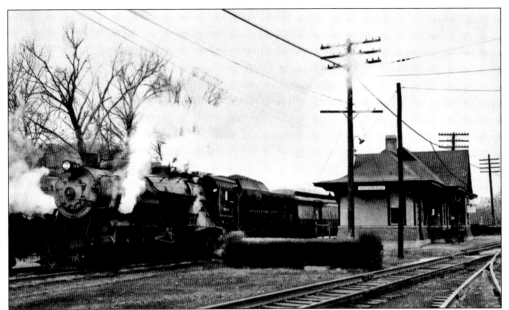

Train 73 calls at the quaint little station at Moundsville in the fall of 1955. In its glory days, one could board trains from here for Wheeling, Pittsburgh, Parkersburg, Huntington, Kenova, Fairmont, and Grafton. Later the building was used in 1971 as a backdrop in *Fool's Parade*, a movie starring Jimmy Stewart. (J. J. Young Jr./Bob Withers collection.)

Wheeling's massive French Renaissance Revival passenger station, seen here from the cab of a diesel locomotive in December 1950, was fashioned of handmade red brick with a granite base and Indiana limestone facing. At one time, the 1908 passenger palace was considered the largest such structure owned and operated by a single railroad; today it is home to the West Virginia Northern Community College. (J. J. Young Jr./Bob Withers collection.)

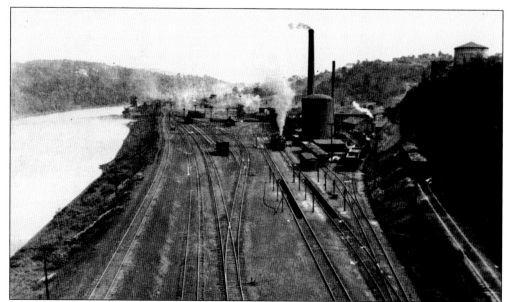

The B&O shop and roundhouse in Fairmont are seen from at a coaling station in the 1940s. The track at left is the main line to Connellsville, Pennsylvania. Note the two holes in tracks at right center. They are inspection pits, where the photographer checked the bottoms of incoming locomotives for 36 years. (O. V. Nelson/Bob Withers collection.)

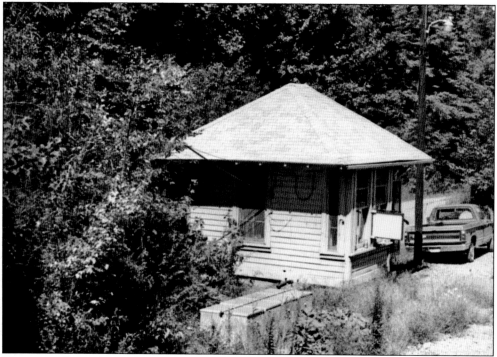

This tiny office is located at Berryburg Junction on B&O's busy Grafton-Cowen coal-hauling line on Saturday, September 14, 1985. These days, the line is leased by CSX Transportation to the Appalachian and Ohio Railroad, and train operations are no longer governed by train orders delivered by operators located along the line. (Bob Withers collection.)

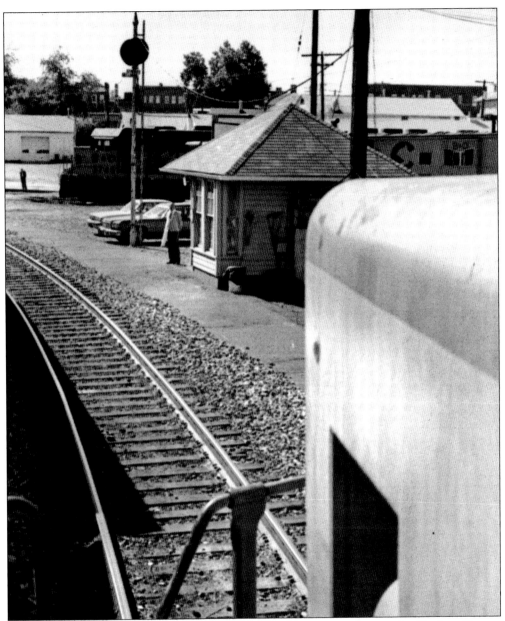

An excursion arrives at the operator's office at Buckhannon—also on the Grafton-Cowen line—on Saturday, September 14, 1985. The 13-car special will continue 1.9 miles to a siding at Upshur, where the locomotives will run around the train and return its passengers to Grafton. At about the beginning of the 20th century, B&O recognized the potential of the region's Gauley coalfields. The company began acquiring and tying together predecessor railroads and running branches up one hollow after another. Then, after World War II, the property was extensively renovated and strengthened. B&O hauled 3.4 million tons out of the area in 1950, compared to 14,000 tons in 1938. The company's 1957 mine directory listed 77 loadouts along all lines south of Grafton, although some of them handled only a few cars at a time. By the mid-1960s, B&O was hauling an astonishing 2,500 loads a week out of the field. The Buckhannon office, seen from the excursion's locomotive cab, also is gone today. (Bob Withers.)

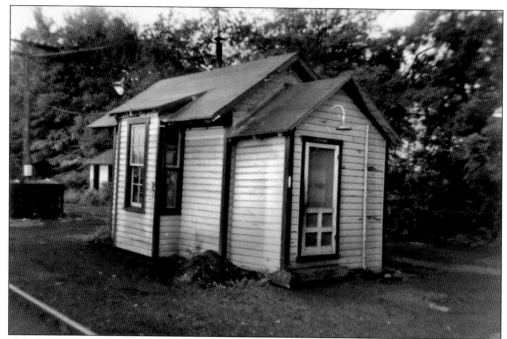

This is one of B&O's relatively rare one-story towers—WN—as seen at Cowen on Tuesday, July 21, 1964. Today the operators are gone and the building has been replaced by a modern steel structure that serves as an office. Cowen still serves as the busy southernmost operating terminal of the Appalachian and Ohio Railroad. (Jan G. Weiford/Bob Withers collection.)

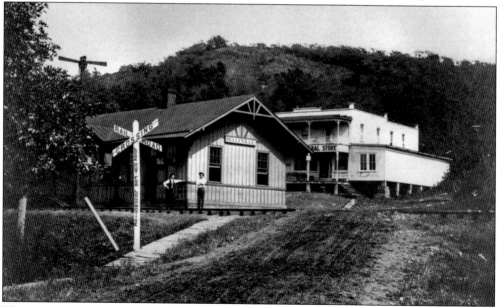

The 1913 Ohio River flood destroyed the original Belleville station, but the town remained an important stop for years afterward. On Thursday, August 3, 1944, fireman Harry Nixon got in trouble with the brass because he neglected to tell his engineer on Train 72 that their meeting point with 73 had been changed until after the engineer stopped a second time to enter the siding at Belleville. (Bob Withers collection.)

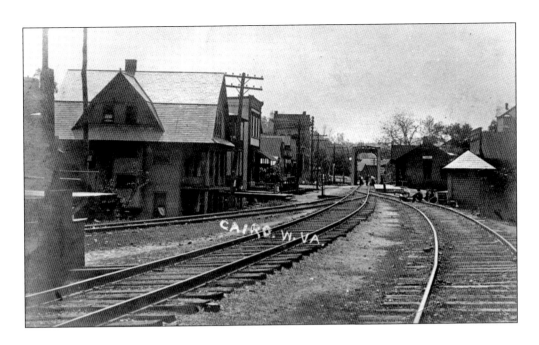

Cairo, above, and Wolf Summit, below, both seen *c.* 1920, were stations on B&O's busy Parkersburg-Clarksburg line. Most of the road's important passenger trains and quick-dispatch freight trains between Baltimore and St. Louis rumbled through the territory at night, vying for valuable space on the main line and several sidings. Things were especially tight during World War II after adding the long trainloads of oil diverted from oceangoing freighters because of the threat of attack from German U-boats. Harold F. Lydick, Parkersburg's terminal trainmaster, reported dispatching 26,091 freight cars in December 1941 alone, compared with 17,923 during the same month a year earlier. (Both photographs Baltimore and Ohio Railroad Historical Society, Inc./ Bob Withers collection.)

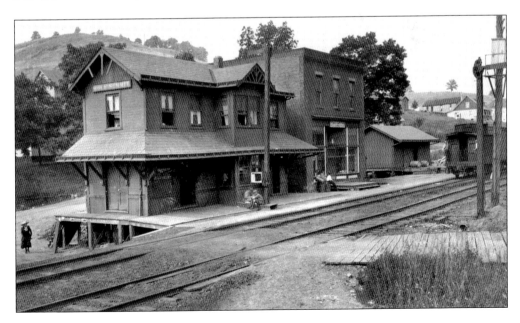

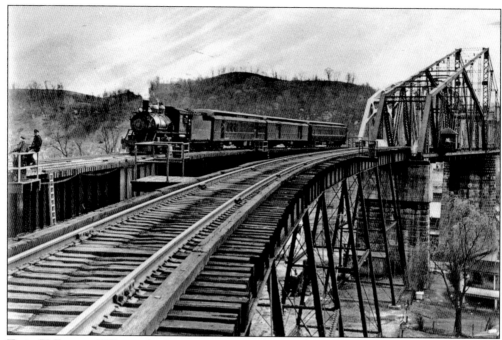

Train 72 Engine 1377 was the first train to cross the new $2-million bridge across the Kanawha River at Point Pleasant in Mason County. It's 2:40 p.m. on Thursday, April 17, 1947, and once other bridges between "the Point" and Kenova are strengthened, larger locomotives will replace the elderly 10-wheelers. The 1887 bridge at right long outlived its usefulness, crippling the Ohio River line for years. (*Herald-Dispatch*/Bob Withers collection.)

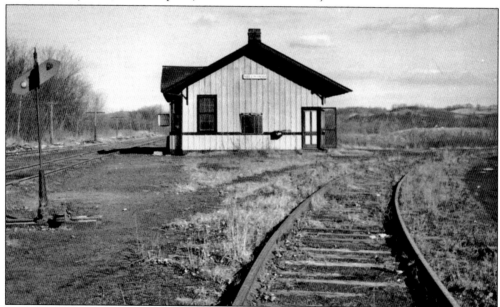

The station nestled inside the wye at Millwood is a scant five miles or so from the busy Kaiser Aluminum plant on the Ohio River line, but here it looks like it is at the ends of the earth. The photograph was snapped just after the agency closed on June 30, 1962. The old building died without ever having electricity or a telephone. (John P. Killoran/Bob Withers collection.)

Eight

TRACKWORK

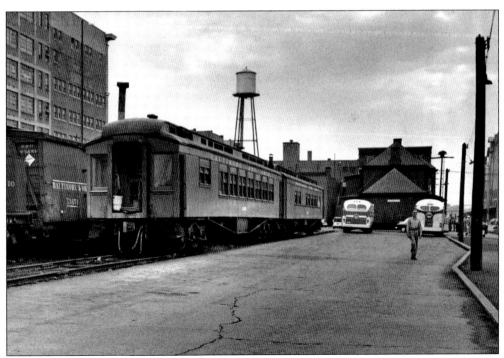

Spotted near the B&O station in Huntington, two ancient passenger coaches that have been relegated to camp-car status provide housing for an extra signal force in the summer of 1952. The first car is a diner, the second a sleeper. Notice the buses—Greyhound also used the B&O station from December 1945 to December 1952. (Charles Lemley/Bob Withers collection.)

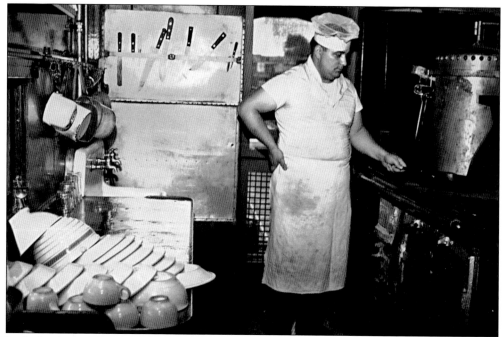

In the kitchen of Camp Car X4205, the chef prepares breakfast for the hardy crew that will install flashing-light signals at road crossings in the vicinity of Huntington in the summer of 1952. There is a place for everything and everything is in its place: that's a railroad signal gang's kitchen. (Charles Lemley/Bob Withers collection.)

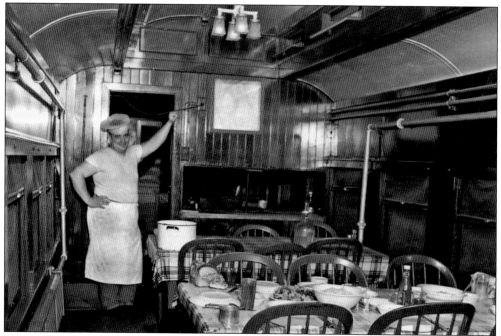

"Come, for all things are now ready." It is doubtful that the camp-car cook's mind was on Luke 14:17, but he obviously is proud of the tables he has set for the signal gang preparing to walk over from the sleeper for breakfast. (Charles Lemley/Bob Withers collection.)

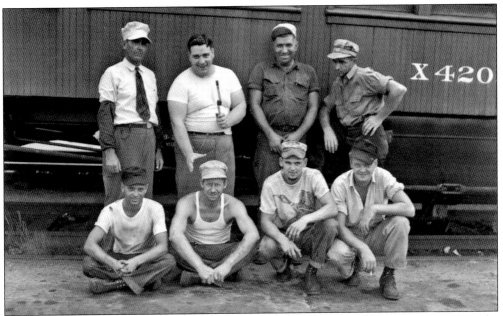

The fellow standing next to the man who appears to be the signal force foreman seems to be engaged in a little horseplay as the photographer gathers the crew for a picture. Likely it is one of the last times the guys down in front will be able to sit down, at least until lunch. (Charles Lemley/Bob Withers collection.)

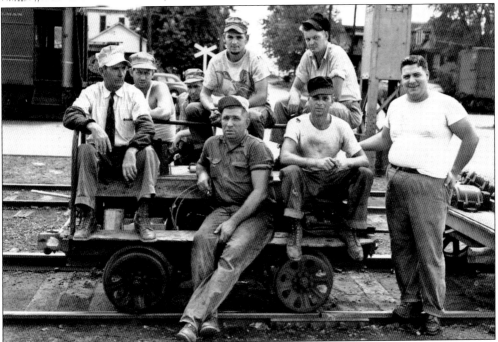

Breakfast and the photograph session—well, most of it—is over now, and the crew prepares to head out for a day of hard work on their tiny motorcar and trailer. Notice the sleeper in the left background—it is assigned to the Pittsburgh-Huntington line; having arrived that morning on Train 77, it will return north that night on Train 78. (Charles Lemley/Bob Withers collection.)

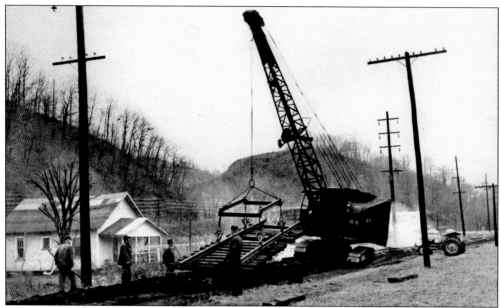

One of the first moves toward more economical operations when the Chesapeake and Ohio Railway took control of B&O in 1963 was a plan to consolidate the B&O and C&O yards in the Huntington area. The unification rendered B&O's eight miles between Huntington and Kenova superfluous, so here, on Thursday, January 6, 1966, track gangs are ripping up panels of track and placing them in gondola cars for use elsewhere. Some B&O yard tracks will survive in order to maintain access to industries not served by the original C&O. The B&O passenger and freight stations will be preserved and become part of a retail development called Heritage Village. (Both photographs Bob Withers.)

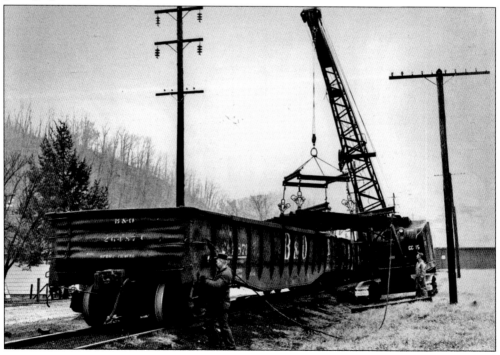

Nine

PEOPLE

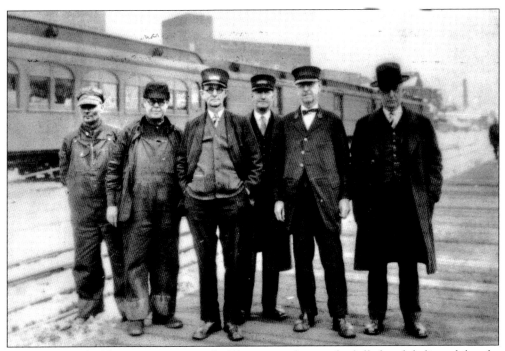

B&O's most valuable asset was its people. They seemed not only skilled and dedicated, but far more personable than many—taking the time to pique the interest of youngsters who might grow up to go to work on the trains. Here a crew poses in Grafton *c.* 1910. (Bob Withers collection.)

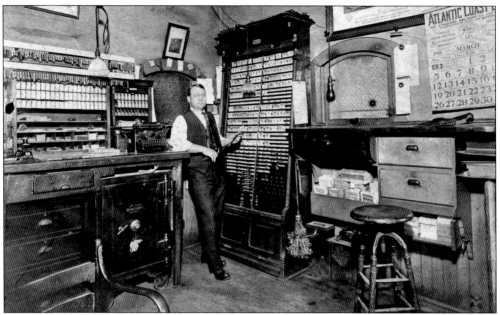

The safe, ticket rack, rows of rubber stamps with station names, bin stuffed with timetables, and even the feather duster hanging near them show how busy the Huntington ticket office was in March 1916, when ticket agent George M. Moore posed for this photograph. It seems everyone traveled by train in those days. (Charlotte Dugan Moore/Bob Withers collection.)

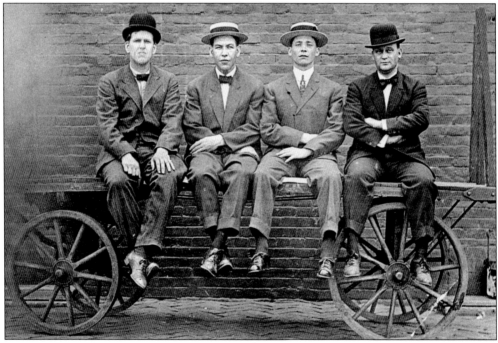

Busy as it was, the Huntington ticket office still enjoyed moments of down time. Here four dapper young men—George Moore is on the right—pose on a station baggage cart beside the station c. 1915. Which is more up to date—the derbies or the straw hats? (Eloise Hines/Bob Withers collection.)

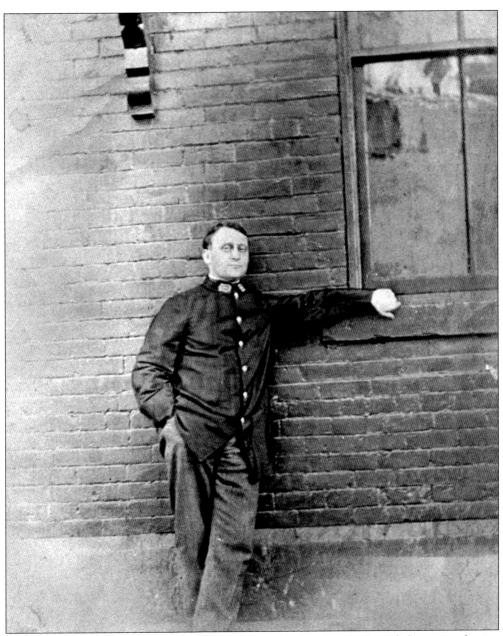

Huntington ticket agent George M. Moore takes another break *c.* 1920. With four pairs of trains calling every day, his office usually stayed busy. Ralph W. Brafford, who worked as a yard clerk on the 3:00-to-11:00 p.m. shift in those days, once recalled during an interview that he often volunteered to go downstairs and help ticket agent Walter Bowman sell tickets to long lines of customers. "About an hour before our overnight train to Pittsburgh, people would line up 20 to 25 deep at both cages," Brafford said. "Walter would take his cash drawer out of the rack to keep from opening it so often and I've seen him throw his change aside and sort it out later." Garland T. Brown also recalled those days for an interview. "I sold $1,800 worth of tickets [one] night for one train, mostly coach and Pullman fares for Wheeling and Pittsburgh." (Eloise Hines/Bob Withers collection.)

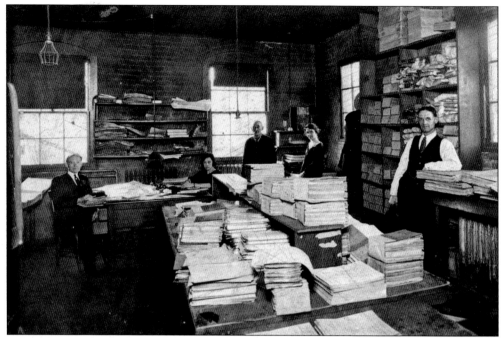

Behind the passenger station, clerks also stayed busy in the freight house office keeping track of cargoes, locating empty cars for local customers, and soliciting new business. Here in December 1923 are, from left to right, Grover Chambers, Pearl Dugan, "Dad" Mayo, Anna Meisenzall, and Tom Stuart. (Charlotte Dugan Moore/Bob Withers collection.)

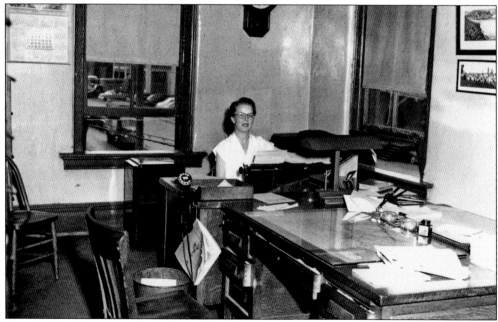

Bea Lawwill, a clerk in Huntington's district freight office, smiles for the camera in June 1951. Bea found work with the railroad during World War II, when so many railroad men went off to battle. She made a career of it, working for 20 years in Huntington and Parkersburg. (Charles Lemley/Bob Withers collection.)

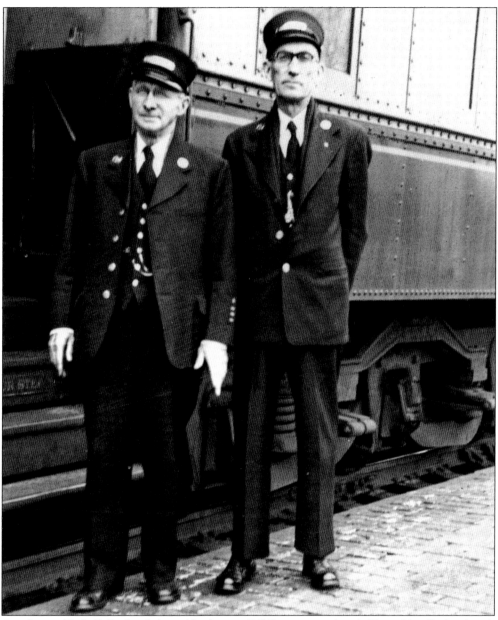

Conductor Clyde E. Barker, left, and brakeman Bill Downs pose beside Train 73 at Parkersburg's Ann Street Station in August 1948. "Great buddies to me," the photographer typed on the back of the print. That seemed to characterize the courtesy and helpfulness of most B&O passenger crewmen in those days. A story is told about conductor J. P. Duvall, who once encountered a passenger who had boarded at Wheeling for Pittsburgh and who became irate when he learned the train did not have a diner. Duvall was especially apologetic because the man had only 19 minutes in Pittsburgh to cross the Monongahela River and catch a connecting train. "Well," the gentleman exclaimed. "I did not eat anything before getting aboard because I wanted to get one of the B&O's fine meals, and I am as hungry as the deuce!" Duvall excused himself, returned quickly, and gave the man two apples from his own lunch pail. Not only was the passenger's animosity overcome, but he was profuse with gratitude. (O. V. Nelson/Bob Withers collection.)

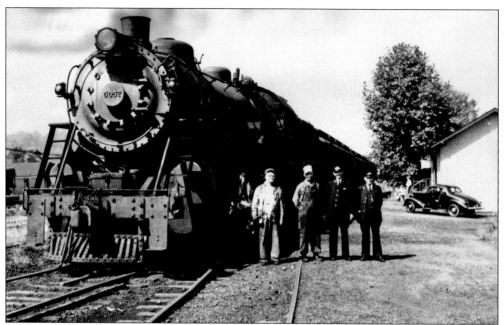

Friendly crewmembers pose for a photographer just before Train 72's departure from Kenova at 10:30 a.m. on Thursday, May 12, 1949. From left to right, they are engineer Less Dyke, fireman John Lightner, flagman Bob Cariens, and conductor John P. Hill. The baggage master must be elsewhere, tending to someone's luggage. (Leo Harmon/Bob Withers collection.)

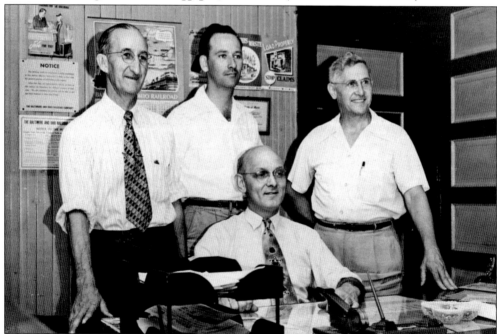

B&O men pose in Huntington's freight house office in June 1951. Ralph W. Brafford, chief clerk, is seated at his desk. Standing around him, from left to right, are cash clerk Clarence Duvall, bill clerk Charles Lemley (who rigged the camera to fire after he jumped into the picture), and rate clerk Herschel Rhodes. (Charles Lemley/Bob Withers collection.)

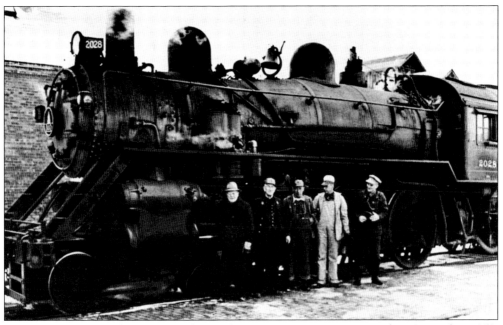

Train 457's crewmembers pose in front of Engine 2028 in Ravenswood in December 1953. From left to right, they are baggage master Charles Shank, conductor Tommy Thompson, flagman Leslie Bolinger, engineer James Welch, and fireman P. D. "Pearly" Randolph. An operator found the photograph years later behind a cabinet in the station. (Esther Morrow/Bob Withers collection.)

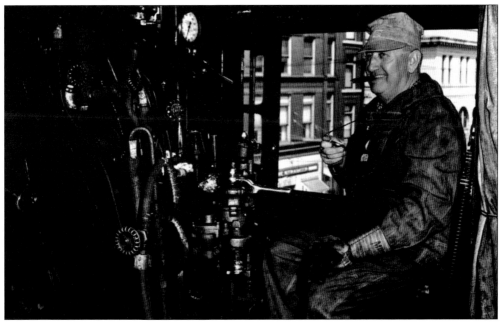

Engineer Roy Roush checks his pocket watch before departing Wheeling's elevated station tracks with Passenger Train 73 in June 1954. Roush retired later that year—the night trains between Wheeling and Kenova had been dropped in 1953, and diesels were on the way. The old hogger knew railroads of the future would not be as much fun. (J. J. Young Jr./Bob Withers collection.)

Operator Francis South hands up orders to the engineer of Train 98, a Parkersburg-Benwood freight train, at SW Tower in McMechen during a snowfall in January 1954. South has clamped the orders—which are affixed to a length of twine—around the top of a Y-shaped hoop so the engineer can run his arm through the open area of the Y and snag the orders "on the fly." The author, who had several pieces of company mail he wanted to send, tried a similar stunt on Tuesday night, February 8, 1966, with an old hoop he owned and with the complicity of engineer John Lightner on Train 104. On the first attempt, Lightner's arm sailed right over top of the hoop. On the second attempt two miles up the track, the engine struck the hoop, breaking the twine, and scattering the mail everywhere. On the third attempt another four miles eastward, Lightner slowed to 10 miles an hour and sent his fireman down the cab's ladder to take the materials out of the author's hand. (J. J. Young Jr./Bob Withers collection.)

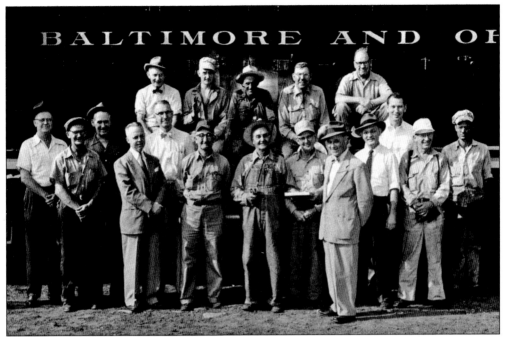

The fellow with the fishing rod is yard foreman Elmer Ansel, who is retiring on Wednesday, September 15, 1954. Colleagues include, from left to right on the locomotive, Charles Beckley, Clyde Woods, Paul Fry, Harry Mitchell, and Howard Harvey. Standing are Henry Lyng, Walter MacElfresh, Bernie Martin, Bill Moore, Wallace Brown, Chester Duvall, Ansel, Dayton Casto, E. W. Reddington, Ralph Brafford, John Lemley, Joseph Pickens, and John Young. (Charles Lemley/Bob Withers collection.)

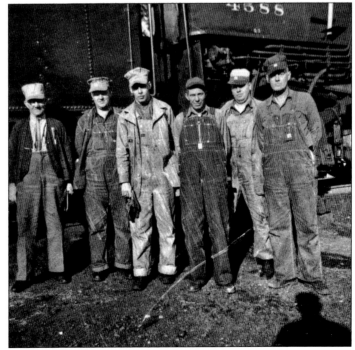

Crewmembers on a doubleheaded mine run pose near Compass No. 2 mine at Dola c. 1956. They include, from left to right, conductor Clyde Townsend, fireman Russell Glover, engineer Charles Hughes, an unidentified flagman, fireman Ira Starkey, and brakeman D. L. Murphy. Mine runs often employed two engines—the lead locomotive picked up cars from mines with trailing point switches; the pusher handled loadouts with facing point switches. (Charles Hughes/Bob Withers collection.)

Operator Paul Maxwell repeats a train order for an oncoming train at SW Tower on Saturday, February 23, 1957. Dispatchers located in Wheeling controlled their trains by dictating orders to operators along the line, spelling important terms such as station names, times, and numbers. As each operator repeated the order, the dispatcher underscored his copy of the order to ensure accuracy. (J. J. Young Jr./Bob Withers collection.)

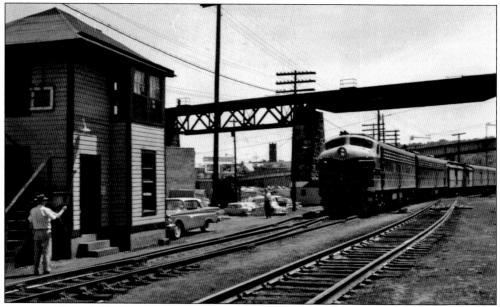

Operator Claire Gibbs prepares to hand up orders to Train 12, the eastbound *Metropolitan Special*, at SX Tower in Parkersburg's Low Yard at 2:11 p.m. on Friday, July 5, 1963. It is a unique summer indeed on the Ohio River line, as through passenger trains are being rerouted around tunnel work on the Parkersburg–Clarksburg main line. (Bob Withers collection.)

It is 7:04 p.m. on Friday, July 5, 1963, and second trick operator Betty Martin Lehew has relieved day trick operator Claire Gibbs at SX Tower. She is all business at the moment, repeating a train order to the dispatcher that she will deliver to departing Freight Train 93 a little later. (Bob Withers collection.)

This is Opal Martin Affolter, Betty Lehew's sister, who also worked at SX Tower. Both women possessed nerves of steel, which came in handy when they worked night shifts at remote offices. One night as Opal was walking back to her car in the rain, a man grabbed her. Reflexively she grabbed a pistol in her pocket and fired it. That took care of Mr. Stalker. (Nancy Taylor/Bob Withers collection.)

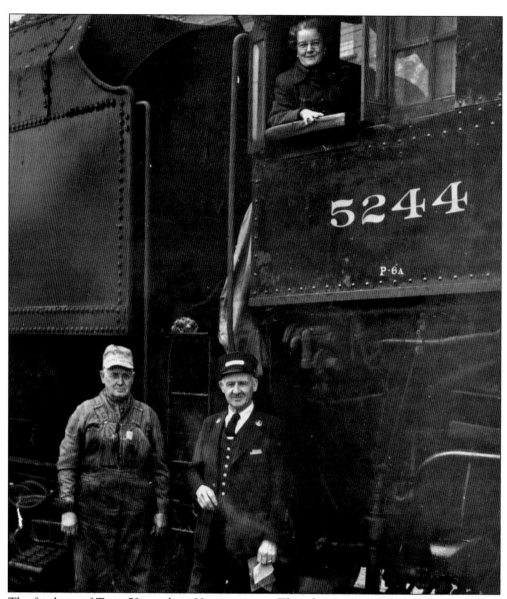

The final run of Train 72 stands in Huntington on Thursday, January 31, 1957. Engineer M. J. Reed (left) and conductor Herbert Sammons pose on the ground while freight office clerk Bea Lawwill visits the locomotive cab. More than 20 retired railroaders and their wives made the sentimental journey, more than No. 72 had carried in years. When B&O first applied to the West Virginia Public Service Commission in 1955 to discontinue Wheeling-Kenova Trains 72 and 73, it moaned that during a typical month, the trains carried only 12 passengers per trip, down 80 percent from 1946, and cost the railroad $18,783 more than they earned. When the Post Office Department removed their mail effective September 1, 1955, the annual loss ballooned from $225,000 to $423,000 overnight. B&O didn't win approval to drop them, though, until Pennsylvania authorized axing their Wheeling-Pittsburgh connections and loadings plunged again to fewer than two people per trip. The next day, B&O bragged that its passenger service was now 100 percent dieselized—ignoring a steam-powered local that still operated between Parkersburg and Kenova. (Charles Lemley/Bob Withers collection.)

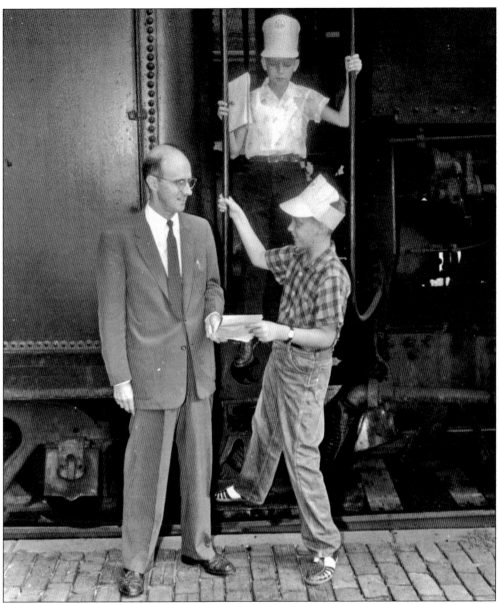

The author—who, when he was 12, went by "Bobby" and was a good bit thinner—shows his notebook to George S. Wallace Jr., assistant company counsel and a member of the Railroad Community Committee of the Huntington Area, as Mike Sellards, 11, looks on from above. The scene was posed on Train 82's locomotive on Saturday, August 31, 1957, to illustrate a newspaper story about the boys' railroad hobby that ran in the Sunday *Herald-Advertiser* on the following September 8. Most grown-ups who read the piece found it astonishing that the boys could identify which steam locomotives were passing while they were in bed at night merely by listening to their whistles, but old-time railroaders not only could do that but nearly as often identify the engineers too. After the photograph was taken, the boys had planned to shell out 26¢ apiece and ride the train to Guyandotte, but they ran into an anomaly—a grumpy B&O conductor who refused to accept their money. They made up for the missed trip many times in later years. (*Herald-Advertiser*/Bob Withers collection.)

The yard office force, still housed in Point Pleasant's old union depot on Thursday, July 7, 1960, poses for the photographer. They are ticket agent/operator G. H. Baker (left) and freight agent Bidwell Glover. Glover tagged the author with the nickname "Guyandotte Yardmaster," which crews employed for years when they threw off clumps of used paperwork for his archive as trains passed. (Bob Withers collection.)

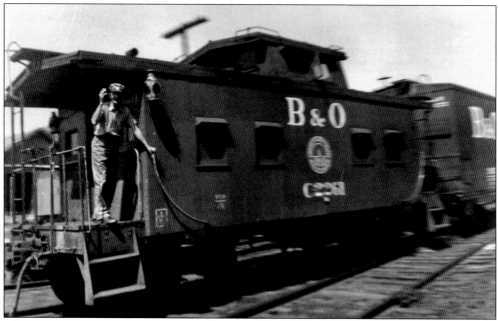

Flagman Bob Cariens offers a warm smile and a hearty wave as mixed passenger and freight Train 82 leaves Point Pleasant on Thursday, July 7, 1960. The train had barely three months to live, but it made little difference to Cariens. He soon would be heading into retirement anyway. (Bob Withers collection.)

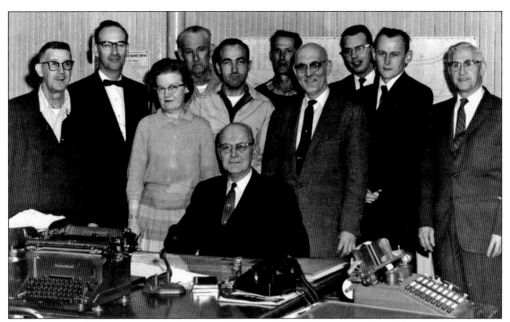

Colleagues wish Huntington freight house foreman Henry Lyng, seated, a well-earned retirement on Friday, March 24, 1961. Standing from left to right are signal maintainer Walter MacElfresh, bill clerk Charles Lemley, freight office clerk Bea Lawwill, yard clerks Bernie Martin and Charles Pastorius, tallyman Ed Simmons, chief clerk Ralph Brafford, district freight agent Charles Barnes, agent/yardmaster Edwin F. Hirzel, and rate clerk Herschel Rhodes. (Charles Lemley/Bob Withers collection.)

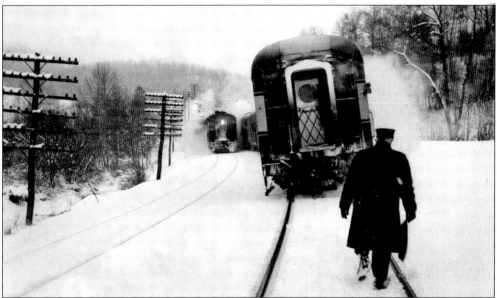

Flagman Charles Morrow heads for the warmth of Train 12, the *Metropolitan Special*, at Berkeley Run Junction on Sunday, January 23, 1966. He had been protecting his train against following movements while it was waiting for Train 11, now in sight, to pass. Morrow's engineer is calling him with four long blasts of the horn, and the photographer is afraid he will be left behind in the storm. (Bob Withers collection.)

www.arcadiapublishing.com

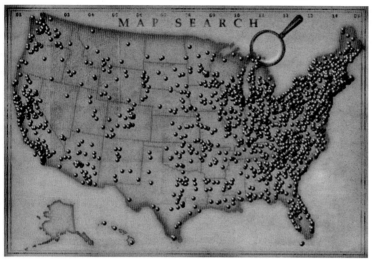

Discover books about the town where you grew up, the cities where your friends and families live, the town where your parents met, or even that retirement spot you've been dreaming about. Our Web site provides history lovers with exclusive deals, advanced notification about new titles, e-mail alerts of author events, and much more.

MADE IN THE USA

Arcadia Publishing, the leading local history publisher in the United States, is committed to making history accessible and meaningful through publishing books that celebrate and preserve the heritage of America's people and places. Consistent with our mission to preserve history on a local level, this book was printed in South Carolina on American-made paper and manufactured entirely in the United States.

This book carries the accredited Forest Stewardship Council (FSC) label and is printed on 100 percent FSC-certified paper. Products carrying the FSC label are independently certified to assure consumers that they come from forests that are managed to meet the social, economic, and ecological needs of present and future generations.

FSC

Mixed Sources
Product group from well-managed forests and other controlled sources

Cert no. SW-COC-001530
www.fsc.org
© 1996 Forest Stewardship Council

Find Your Place in History.